SIMPLY PAINTING

FRANK CLARKE

Published by

 ART GALLERY

First Published October 1992, Oisin Art Gallery,
44 Westland Row, Dublin 2, Ireland.
Second printing July 1993

Text and Drawings © Oisin Art Gallery and Frank Clarke
Jacket Design © Oisin Art Gallery and Frank Clarke
Layout and Design by R. McNeela and D. McNeela
Co-ordination and Distribution by Oisin Art Gallery
Photography by Stephen Travers and Danny Fernandez
Origination & Typesetting by Typeform Repro Ltd.
Colour Reproduction by Typeform Repro Ltd. & Colour Repro Ltd.
Printed in Ireland by Smurfit Web Press Ltd.

Paperback ISBN 0 9512510 4 X

Dedication

I dedicate this book to my wife Peg and my sons Jason, Clive and Rolf.

Appreciation

To Rory and Donal who are my publishers and friends. To Jimmy and Deirdre, thanking them for all their support, without whom this book could not have happened. To Pat Liddy for his generous and professional assistance. To John McMahon of R.T.E. who has given me great support over the past few years and last but by no means least all the people who had faith in me and my teaching methods.

Contents

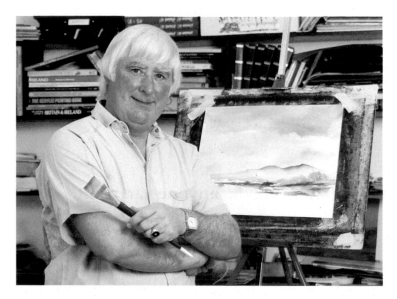

Who is Frank Clarke?

Born in Dublin, Ireland, Frank Clarke is a self taught artist who did not begin to paint until he reached his late thirties. Today he is one of Ireland's most well-known and sought after artists.

Frank developed a unique approach to painting which prompted him to begin teaching. This approach has turned many complete beginners into confident and competent artists in a matter of hours.

The success of Frank's classes using his *"Have Some More Fun"* technique, together with his relaxed style of presentation has led to the production of several highly successful television series and a series of videos for Warner Home Video, a Warner Communications Company.

Frank to date, has had over twenty one-man exhibitions and his pictures are in the private collections of many of the rich and famous worldwide.

His two great loves in life are painting in the West of Ireland and his teaching. "I can't make my mind up which gives me the greater pleasure; painting in my beloved Connemara or the look of joy on a beginner's face when their first picture is framed".

Introduction

As the name suggests **Simply Painting** is a simple no-nonsense method of painting with watercolours. It is my belief that learning to paint should be fun and that by using the step-by-step method contained in this book, **anyone can paint**.

I have proved this point both on my television series and at my demonstrations when I asked a non painting volunteer to come and paint a picture. The results have amazed both the volunteer and the audience.

So believe me when I say anyone can paint a picture. **I have yet to meet a failure**.

Now let me introduce you to your new friend **Mr. Brush** whose purpose is to guide you through this book.

1: Painting is Simple

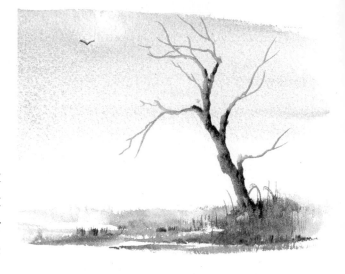

The purpose of this book is not only to teach you to paint, but to unlock the natural talent for painting that is already inside you.

Painting is an exhilarating hobby, a rewarding craft, a delightful means of self-expression and self-discovery, and a noble art-form. And, it can be great fun.

Unfortunately centuries of snobbery, waffle and misleading nonsense have convinced many people that painting is a highly complex art only possible for the select few. Millions have been robbed of their birthright by having their inborn artistic talents stifled at an early age.

Simply Painting is designed to awaken your artistic talent and prove conclusively that in the process you can *Have Some More Fun*. This book does not set out to teach you the theory of watercolour painting. Instead it studiously and deliberately avoids all the confusing theories of tones, conversions, perspective and all the tangled terminology which often acts as a hindrance rather than an encouragement to the budding painter.

This book uses a unique new technique in water-colour painting which, for reasons that will become apparent, I have called

Have Some More Fun. That phrase not only sums up the technique used, but it admirably reflects the underlying philosophy that painting is not only simple, but **great fun**.

Yes, you can do it

It is my conviction, as an experienced teacher and dedicated artist, that you can be an active painter before you get to the end of *Simply Painting*.

I sincerely believe that the thousands of people of all ages whom I have observed over the years in my painting classes have proven that **anyone who can draw the letter 'M' can also paint a picture**.

Why not test that claim right now on a piece of paper? Draw the letter 'M' with a straight line underneath – just like **Mr. Brush**.

Congratulations! You have drawn a simple, splendid representation of mountains and a valley. Soon you will learn how to paint them.

It's Never too Late to Start

I discovered I could paint pictures during a particularly wet holiday in Ireland. Up to then, I would have dismissed with a loud guffaw any suggestion that I could paint.

I don't recall what I painted on that first occasion, but I soon discovered I was hooked on painting for life! From the very beginning of my artistic career, I was particularly attracted to watercolour painting. For me, watercolour painting is a much more vibrant medium than oil painting. It is also more flexible and more portable, all you need is a brush, some paper, a few colours and you can paint anywhere.

Painting can be taken up at any age. Many people have been inspired by the story of Grandma Moses, the American Indian artist. In her seventies, Grandma Moses fell upon hard times. She had to scavenge in garbage cans for food and clothing. One day she found a discarded box of paints. At first she had no idea what they were. However, her natural curiosity led her to find out about the paints and what could be done with them.

Within a few years she was one of America's most celebrated and highly paid artists.

At seventy years of age she started a thirty year career as a painter.

It's never too late to start!

2: Watercolours

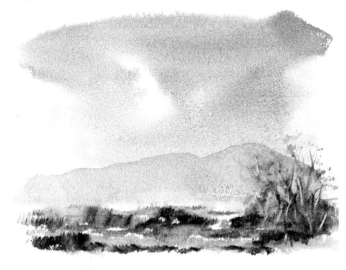

Originally watercolours were only used for sketching by the great artists before they painted a picture in oils. Fortunately today watercolour paintings are equally sought after, so your new hobby may even earn you some extra money.

For me, painting with watercolours is an art in simplification. The more you leave out of a painting the more it will say. Watercolour painting is like a good round of golf. They both have the same golden rule **'the less strokes the better'.**

There is no doubt in my mind that one of the most common factors which ruins paintings by the inexperienced artist is the urge to overpaint. You must resist it! Remember you are not painting a wall or a door where every inch must be covered. Only put in your painting what is really necessary.

In some cases your subject will dictate that the less paper area you cover with paint the better. For example, in a winter scene full of snow, you might only include a bleak lonely tree and a remote cottage and leave the rest of your paper almost blank. In this way the unpainted areas emphasise the presence of snow.

It is important to note that in watercolour painting you don't need white paint. Your white paper serves this purpose. So if you want to feature white in your painting, you **must** leave the appropriate spaces blank .

TIP: To avoid over-painting use a large brush.

You can learn a lot about watercolour painting by looking at pictures painted by some of the great artists such as Turner, Cotman, Cox and De Wint, by attending painting exhibitions in your area and by visiting art galleries.

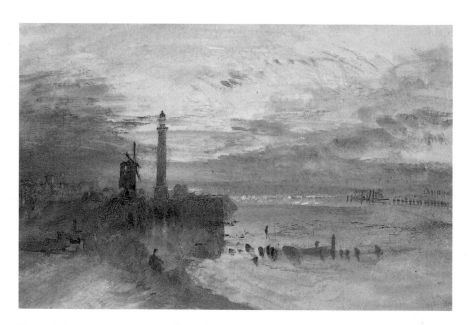

Great Yarmouth Harbour, Norfolk.
Courtesy of National Gallery of Ireland.

J.M.W. Turner

3: Materials

Brushes

To start painting in water-colours, you will need two brushes, one large and one small. For your large one I recommend the 1.5 inch (38mm) Winsor & Newton *Simply Painting* goat-haired brush. I paint about 90% of all my paintings with this brush. It's size not only prevents the overpainting I cautioned you against in the last section, but it also stops you fiddling about adding extra little bits here, there, and everywhere.

For the smaller brush I recommend you purchase the Winsor & Newton *Simply Painting* Number 3 Rigger. The name "Rigger" is derived from the days of old when artists painted the rigging on pictures of ships. A Rigger is a narrow long-haired brush which gives you excellent thin lines. You do not need to buy an expensive sable brush for this purpose, the *Simply Painting* Nylon Rigger will give you excellent results.

Not having the **Simply Painting** brushes does not preclude you from painting the lessons in this book, though they will help. **Any large** water-colour brush can be used, and **any** Number 1, 2, 3 or 4 watercolour brush can be used in place of the Rigger. So you have no excuse.

As you progress you will want to experiment with extra brushes. Do so by all means, but start with the recommended two. In time you will develop a personal attachment to your own favourite brushes, but until then it's far more important that you get started, and in my experience the less cluttered you are, the easier your progress will be.

Paints

There are two forms of watercolour paint; tubes and pans. The paint contained in tubes is moist and ready for use; pans are blocks of paint which have to be softened with water. You will probably remember these from your childhood paint boxes.

To start I recommend Winsor & Newton Cotman watercolours in tubes. I use them myself and suggest you do the same.

You should not rush out and buy a huge selection of colours. Instead start with a minimum number of paints which you can learn to mix to produce other colours.

What Colours Do I Need?

I would suggest you start with the following colours in tubes.

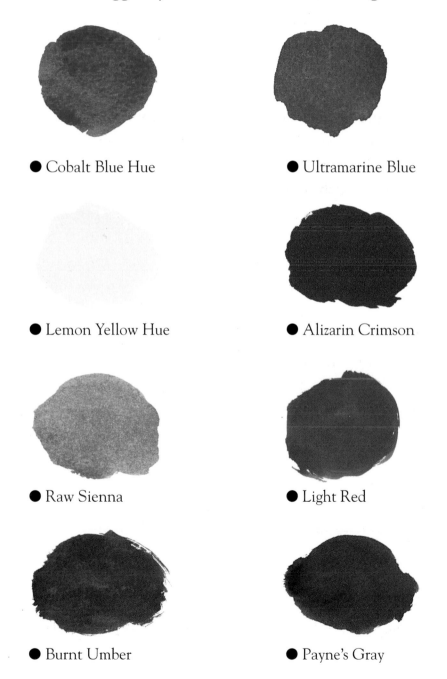

● Cobalt Blue Hue

● Ultramarine Blue

● Lemon Yellow Hue

● Alizarin Crimson

● Raw Sienna

● Light Red

● Burnt Umber

● Payne's Gray

With this recommended selection you will be able to mix all the colours you are likely to need. Notice that I have not included green in the selection. You can obtain a variety of greens by mixing other colours.

For example, Lemon Yellow Hue and Ultramarine Blue will make a green. Raw Sienna and Cobalt Blue Hue will produce another green, while Payne's Gray and Lemon Yellow Hue combine for a third green. In this way you will be able to put together your own repertoire of the proverbial 'forty shades of green' without feeling that you are stuck with the green you bought ready-made in a tube. Since most people take up watercolour painting in order to paint landscapes and flowers your greens are of crucial importance to your work.

As you will discover, mixing your own colours is one of the most exciting aspects of watercolour painting.

Paper

Watercolour paper is available with several surfaces and comes in many weights.

There are three main surfaces of paper:

1. Very smooth known as Hot Pressed.
2. Semi rough known as Not or Cold Pressed.
3. Rough – as the name suggests this paper has a rough surface.

All of the above papers are available in the Winsor & Newton range of watercolour paper and come in many weights (thicknesses) from 90lbs (190gsm) to 400lbs. (900gsm). These papers can be purchased in a selection of formats including loose sheets, gummed pads and spiral pads.

The paper I prefer has a semi-rough surface and is 140lb (300 gsm) in weight. I use this paper because lighter papers tend to pucker when water is applied. It is obtainable from most good art stores and comes in convenient sizes. For the lessons in this book the size I recommend is 10" x 14" (25 x 35cm).

Hot Pressed *Not or Cold Pressed* *Rough*

Board

To paint effectively you will need to attach your paper to a solid surface. Your local hardware store will be able to supply you with a piece of .25" (6mm) plywood (or any hardboard) measuring approximately 20" by 16" (50 x 40cm).

You may even have an ideal piece of flat board lying about the house. Any piece will do provided it's strong enough to give a firm surface beneath your paper.

You will find it more comfortable when painting if you set your board at a slight angle of fifteen degrees. To achieve this you can place an object a couple of inches thick under the end furthest from you. This positioning of the board enables you to view your work easily while allowing the paint to flow naturally down the paper.

At this stage an easel is an unnecessary expense. Some watercolour painters go through a lifetime without using one.

However if you desire to have an easel make sure it is specifically designed for or adaptable to watercolour painting.

There are many ideal metal easels on the market.

Do not be misled into thinking that a 'real painter' always uses an easel. In our case our board is our easel.

Palette

A palette is basically for holding and mixing paint, so virtually any large plate or smooth flat surface will do. Ideally the surface should be white because it will give you a more accurate guide as to how each colour will look on your paper. Personally I use a large, flat, white plastic tray, and this gives me plenty of room to work on.

Avoid using palettes which look like egg-trays.

Hairdryer

This is the **Simply Painting** secret weapon! A small domestic hairdryer will not only speed up the drying time but will give you more control over the drying process. It will also stop you fiddling with your painting through impatience and allow you to move on to the next stage faster.

Masking Fluid

Masking fluid comes in a bottle and can be obtained in most art stores. It is available in two types from Winsor & Newton, coloured and colourless. Both work equally well, however the coloured fluid allows you to see more easily where the fluid is applied.

The reason for using masking fluid is to allow you to paint over an area of your picture without letting the paint get on part of the surface of the paper. Let me explain. If you want to leave a tree trunk white and the rest of the picture blue, sketch the tree trunk in pencil and then paint the trunk with masking fluid.

When the masking fluid is dry, paint the rest of your picture ignoring the tree trunk, you can even paint right over it. The masking fluid won't let the paint get onto the tree trunk. When the paint is dry you can rub off the masking fluid with your finger or an eraser, leaving a white tree trunk. This can then be left white or painted any colour you like. (See opposite page)

Masking fluid can be a great help when painting flowers, boats and cottages, but don't overdo your use of it.

TIP: Be sure to clean your brush with water before the masking fluid dries on it. If it does dry, don't worry, you can remove it using white spirits or a suitable brush cleaner. Use an inexpensive brush to apply the fluid.

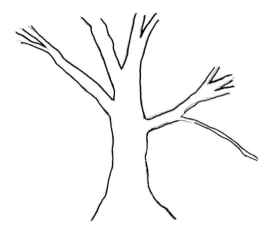

Draw an outline of the tree trunk.

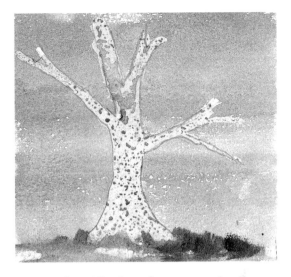

Use Masking Fluid on the tree trunk, then paint in the background and the foreground.

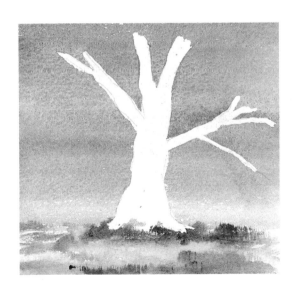

Rub off the Masking Fluid.

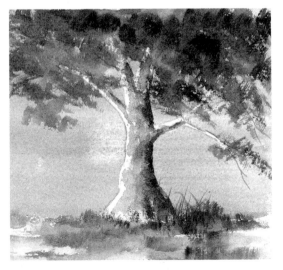

Paint the bark of the tree and the leaves.

Some Other Items

- You will also require a large container for holding water. The larger the container the longer the water will stay clean. Any good-sized bowl or jar will do admirably.
- A pencil, to draw guidelines. A HB grade is best. Don't use a hard pencil it will leave a permanent mark on the paper's surface which can't be erased.
- A roll of masking tape to affix the paper to the board.
- An eraser to rub out pencil lines. This can often be done after your painting is complete, without damaging your work.
- A ruler to draw straight lines. Try to obtain one at least 20" (50cm) long.
- A cloth.

Check List

- 2 brushes, one large, one small
- piece of board 20" x 16" (50 x 40cm)
- roll of masking tape
- paper 140lb (300 gsm), 10" x 14" (25cm x 35cm)
- palette, tray or plate
- cloth
- container of water
- pencil
- ruler
- eraser
- watercolour paints
- hairdryer if you have one
- masking fluid.

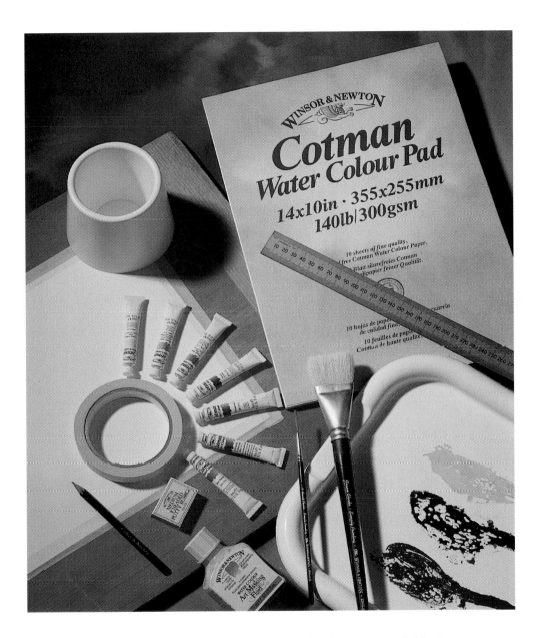

A kit containing most of the materials above is available from
Winsor & Newton through most good art material outlets.

Now Let's Have Some More Fun!

4: Have Some More Fun

Have Some More Fun is the unique technique behind the *Simply Painting* concept.

Some years ago, when I was first asked to give painting lessons, I found my students were making the same mistakes I made as a beginner. Their approach was extremely disordered, their paintings rambled all over the paper and they had no idea what they were going to do next.

Students would paint a tree, then try to paint the sky but in the process, they would "mess up" the tree. Tempers would fray, frustration would grow and at this stage many students gave up.

The problem was not the accidental overpainting of the tree but the student's overall approach to the project. What was needed was a step-by-step technique for structuring their paintings.

So I became determined to devise a formula which would not only be very simple to remember but would also give every student the basic technique to build any landscape painting.

By breaking every landscape into **four distinct components** I found that students began to produce remarkably improved paintings.

Those four components were:

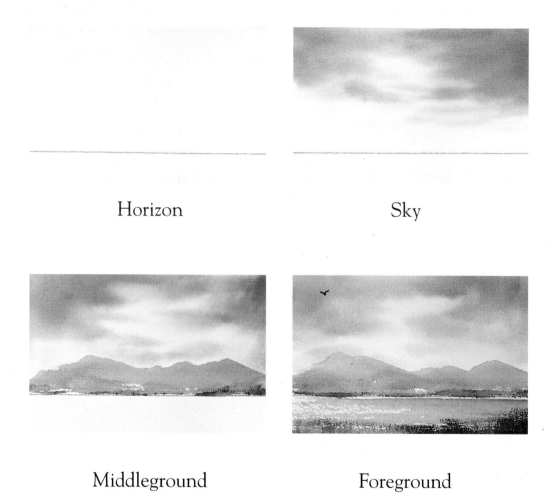

Horizon Sky

Middleground Foreground

Students who used this technique started to enjoy their painting more and their confidence grew in leaps and bounds. Their pride in their finished paintings was a joy for me and they quickly became enthusiasts.

However, I knew I would not be satisfied until I could find a means of indelibly imprinting the formula of **Horizon, Sky, Middleground and Foreground** in the mind of every student who wanted to paint without having to spend years studying.

In due course I found that method in a simple sentence. ***Have Some More Fun***. Once you have learned this four word sentence all you have to do is connect the initial letters.

Have = Horizon

Some = Sky

More = Middleground

Fun = Foreground

Paint your pictures in this order and ***Have Some More Fun***.

Controlling water with your large brush

You are almost ready to start your first painting, but before you do I want to tell you a little about the control of water while you paint. One way to let your picture get out of control is to use too much water.

When you start to paint you need to control the amount of water in your large brush. The most frequently asked question in watercolour classes is "How much water should I use"? The answer I give is "not too much".

So how do you control the water? **With the cloth.**

For the purposes of simplicity let's break the hair of the brush into two parts, the Tip and the Body. The tip is the top half inch (12mm) of the hair and the body is the rest of the hair.

TIP = Top ·5 inch (12mm) of the hair

BODY = The rest of the hair

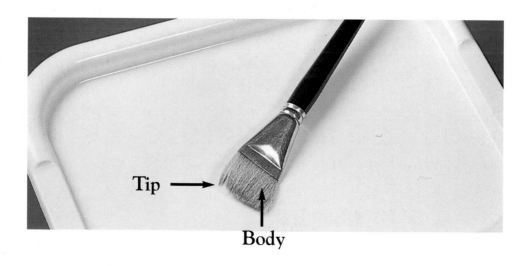

Tip ⟶

Body

When you want to control the amount of water in your large brush this is what you do:

1. Dip your brush into the water.
2. Using your cloth, dry the body of the brush by resting it on the cloth.

DO NOT DRY THE TIP

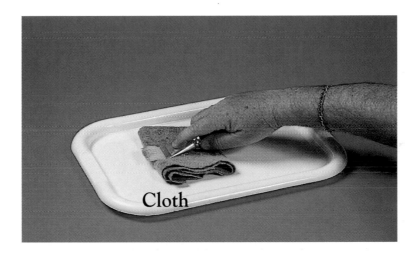

Cloth

This allows the tip to remain wet, and ensures that there is not too much water in the body of the brush.

3. Now dip the brush into the paint and apply to the paper.

This process is repeated **every** time you want to apply paint to your picture.

With a little practice, you will get to know just how much water you need in the large brush.

When wetting the paper without any paint on your large brush there is no need to dry the body with the cloth. Small brushes do not retain much water so there is little need to use this technique with them.

NOW THE FUN BEGINS!

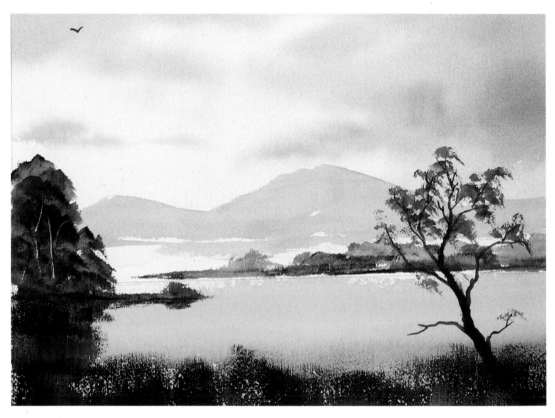

Lesson 1 *Finished painting*

5: Lesson 1

Your First Picture in Watercolour

To paint your first picture you need the following equipment:

- Large Brush – 1.5" (38mm) Winsor & Newton **Simply Painting** Brush
- Small Brush – Winsor & Newton **Simply Painting** No. 3 Rigger
- Burnt Umber Watercolour Paint
- 1 Sheet of 140lb (300gsm) Watercolour Paper, 10" x 14" (25 x 35mm)
- Palette
- Water, Pencil, Cloth, Ruler and Adhesive Tape
- 20" x 16" (50 x 40cm) board
- A Hairdryer, if you have one.

It will help if you read this lesson completely before you start painting, it should only take you five minutes.

To give you a simple introduction to painting, your first exercise is to paint a picture using only one colour. In this case Burnt Umber, the dark brown colour.

By painting with a single colour you will learn how to use water to lighten the colours and that the colour is at its darkest if used undiluted.

This single colour approach is known as 'monochrome' and it's a good way of starting to paint without having to concern yourself with mixing colours.

SO OFF WE GO.

Step 1 Have – Horizon

Affix your paper to your board on three corners – two top and one bottom – leaving one bottom corner free. This will allow your paper to expand and contract without cockling.

Now take the ruler and lightly draw the Horizon line one-third of the way up the paper.

Step 2 Some – Sky

Take the tube of Burnt Umber paint and squeeze some onto the side of your palette.

Dip the large brush into the water and wet the paper to within 1" (25mm) of the horizon line.
Use only water at this stage.

Dip the large brush into the water once more and then dry the body of the brush with your cloth. (See the section on controlling water with your large brush, pages 28 and 29.) Now dip the large brush into the paint on your palette and bring some paint into the centre of the palette making it into a weak mixture. Starting at the top of the paper, paint the sky.

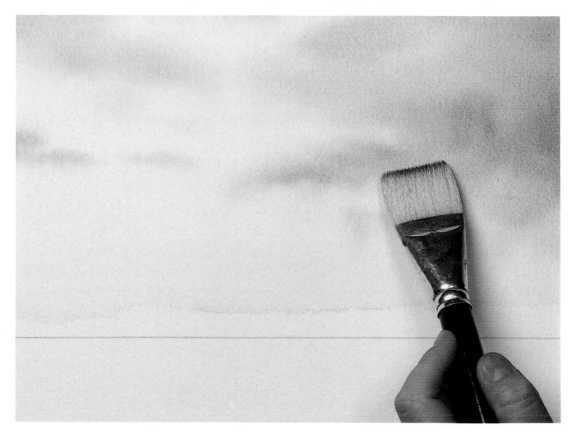

Make sure you leave some blank unpainted areas to represent clouds. Refer often to the finished painting on page 30.

TIP: You should only allow yourself two minutes to paint the sky. This will be explained more fully in the section on skies, page 82.

Step 3 More – Middleground

Wait until the paper is dry before painting the middleground. To check whether it is dry, look at the paper from the side. If it has a shine it is still wet. Either give it more time to dry or use your hairdryer.

In this painting the middleground consists of mountains, riverbank, and the stand of trees on the left.

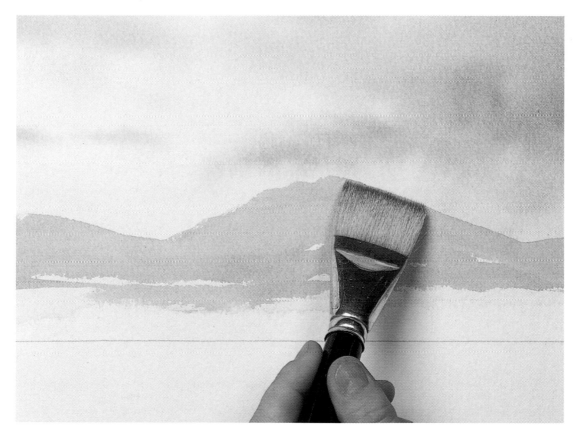

You paint the mountains by taking the large brush and drawing a slightly wobbly letter 'M'. The mixture should be a little darker than that used for the sky, and don't forget to leave some blank spaces. These spaces give texture to your picture.

Allow the painting to dry before continuing.

Many paintings are ruined by not allowing sufficient drying time between stages.

With a darker mixture, i.e using less water, hold the large brush flat (as in the illustration) and dab in the river bank on the horizon line, right across the painting.

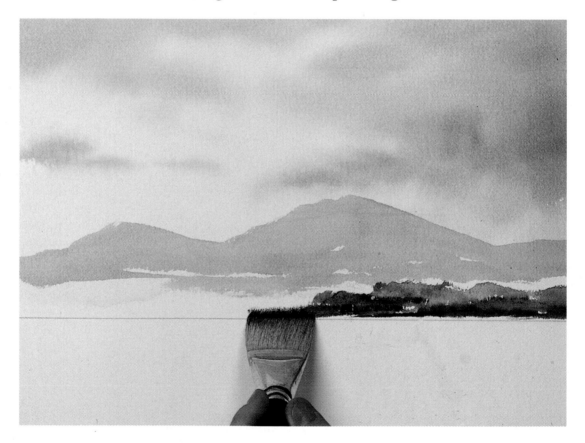

TIP: The drying time can be reduced at every stage of painting by using a hairdryer. This also gives more control over the drying process.

Next paint the water by using single strokes. Put a weak mixture of paint on the large brush. Hold the brush on edge, to give a broad brush stroke and sweep it across. This technique will create blank spaces to represent ripples on the water.

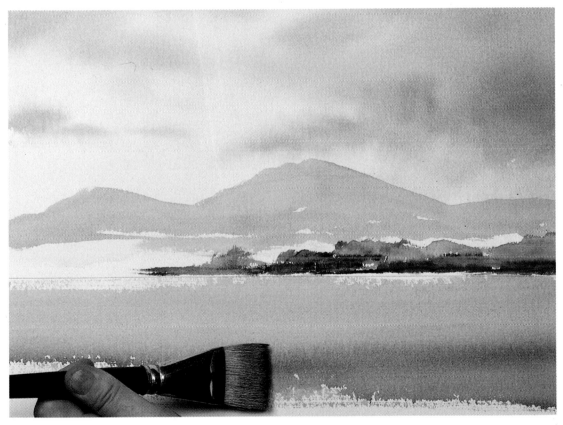

Under your first brush stroke repeat this procedure a second time.

THEN STOP, DON'T FIDDLE, LET IT DRY.

Now paint a little stand of trees on the left side of the painting in the middleground. Use darker paint i.e less water. Keep referring to the finished picture.

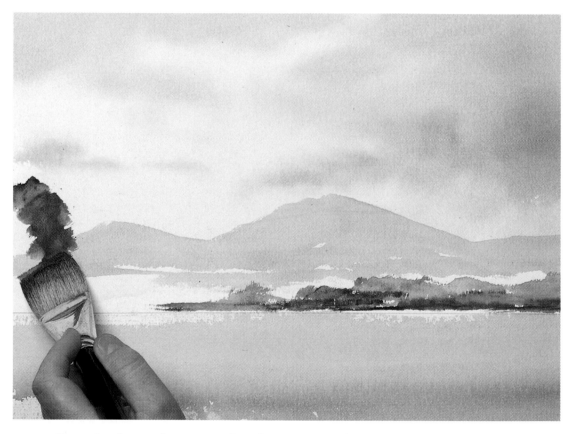

Just before the stand of trees is dry, use your fingernail to 'scrape out' the branches and tree trunk. But don't overdo it!

AGAIN, STOP AND LET IT DRY.

Next you will create the shadow of the trees on the water. You do this by painting a mirror image of the stand of trees beneath the ones you have just finished. Look carefully at the original painting to see how dark they should be.

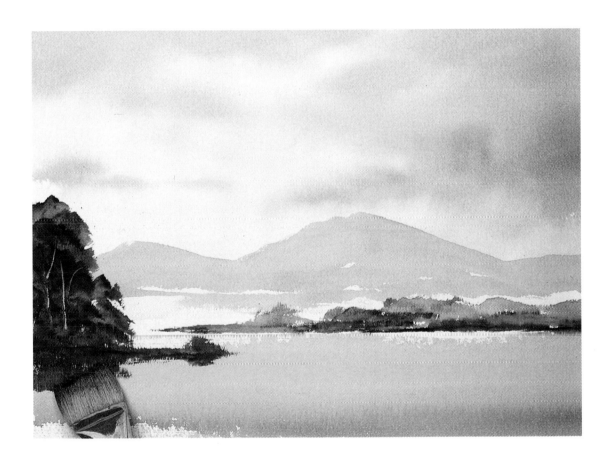

Step 4 Fun – Foreground

Now paint the foreground. With the cloth, dry the large brush. Look at the original painting and paint the rushes using downward strokes of the large brush with plenty of paint and very little water.

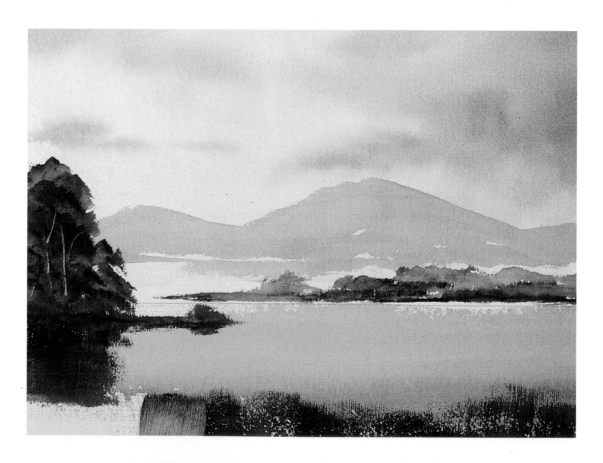

WAIT UNTIL THE PAPER IS DRY BEFORE MOVING ON.

It's now time to use the small brush to paint the tree. Starting from the ground up paint a wobbly line, it's not a telegraph pole!

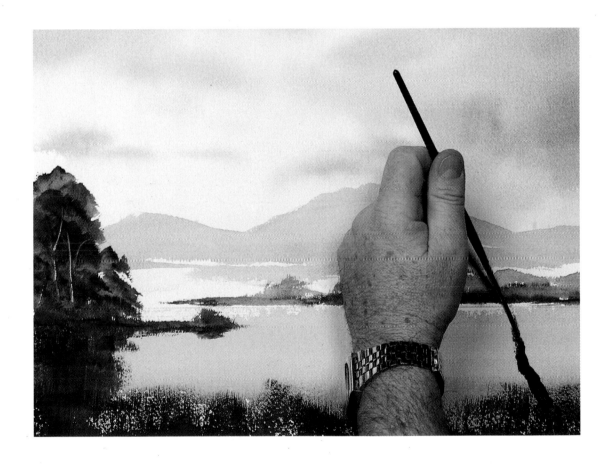

TIP: Always paint trees from the ground up. That's how they grow.

Now put some branches on your tree. Hold the rigger brush like a pen and use the paint as you would ink. Do not put too many branches on the tree.

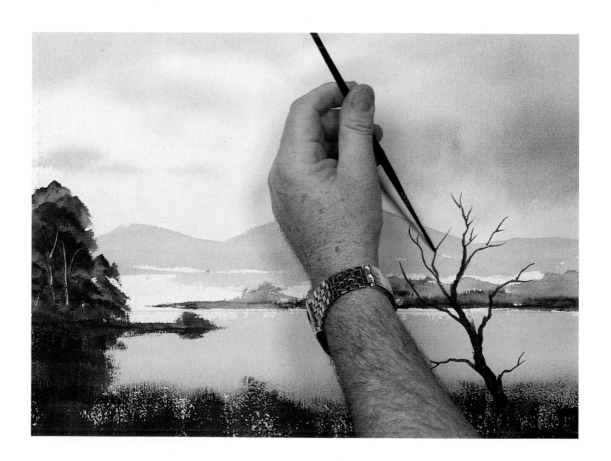

Back to the large brush again. Use it almost dry. Pick up some paint and dab in the leaves of the tree using only the corner of the brush. Again, refer to the original.

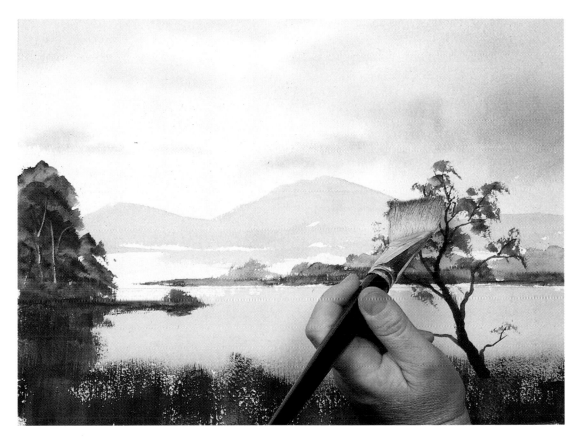

Congratulations!
You have *Simply Painted*
your first painting!
Don't forget to sign it!
Want to *Have Some More Fun?*
Read on.

Lesson 2 Finished Painting

6: *Lesson 2 Landscapes in Colour*

To paint in colour, you will need the following equipment:

- Large Brush – 1.5" (38mm) Winsor & Newton **Simply Painting** Brush

- Small Brush – Winsor & Newton **Simply Painting** No. 3 Rigger

- Paints – Ultramarine Blue, Raw Sienna, Payne's Gray, Lemon Yellow Hue, Burnt Umber

- 1 Sheet 140lb (300gsm) Watercolour Paper 10" x 14" (25 x 35cm)

- Palette

- Water, Pencil, Cloth, Ruler and Adhesive Tape.

- 20" x 16" (50 x 40cm) hardboard

- A Hairdryer, if you have one.

In this lesson you will learn to use several colours using the **Have Some More Fun** technique.

Step 1 Have – Horizon

First affix your sheet of paper by three corners to your board with tape. Two top and one bottom.

Take your ruler and pencil and draw the horizon line, one-third of the way up the paper.

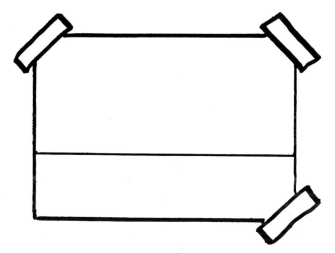

It is important at this stage to look closely at the finished painting.

Step 2 Some – Sky

You will need Ultramarine Blue for the sky so squeeze some of this colour onto the lower left corner of your palette.

Take the large brush and, using water only, wet your paper from the top down to within 1" (25mm) of the horizon line.

Now take the large brush and dip it into the Ultramarine Blue paint.

Starting from the top of the paper, paint the sky with the Ultramarine Blue. Use the same method you used in the first picture. Leave some white paper showing. As you go down the paper use less paint, more water. Don't fiddle, two minutes is all the time you have to paint the sky.

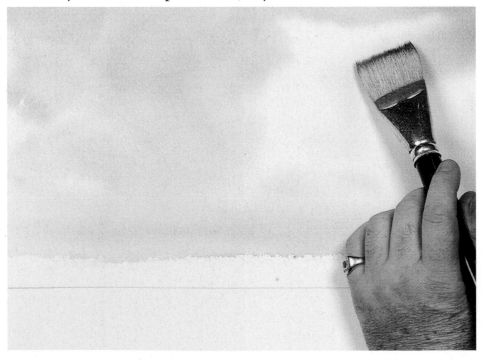

NOW LET IT DRY!

Step 3 More – Middleground

The middleground in this picture is the mountains and distant bogland. To paint the mountains you need a mixture of Ultramarine Blue and Payne's Gray. Put some Payne's Gray on the left upper corner of your palette. Mix a <u>little</u> (very little) Payne's Gray with Ultramarine Blue.

Now paint the mountains. Again I refer you to your first painting. The same applies here, paint a slightly wobbly letter M only this time use the mixture of Payne's Gray and Ultramarine Blue. Don't forget to look at the finished picture for this lesson.

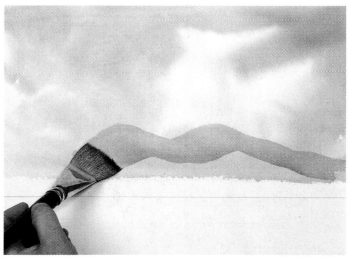

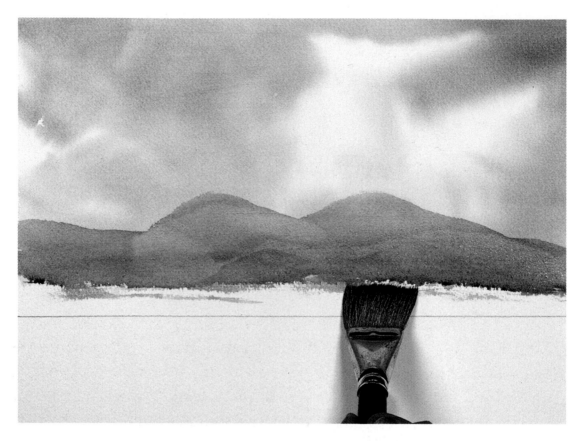

Now squeeze some of the remaining three colours, Raw Sienna, Lemon Yellow Hue, and Burnt Umber onto your palette.

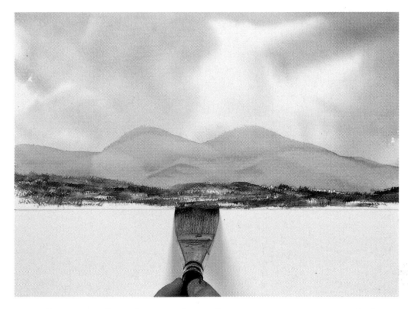

With an almost dry large brush, use separate dabs of Raw Sienna, Burnt Umber and Lemon Yellow Hue to paint the middleground. Paint with short downward strokes, as you did when painting the rushes in the first lesson. There is no need to clean your brushes between colours. Remember to leave some blank spaces.

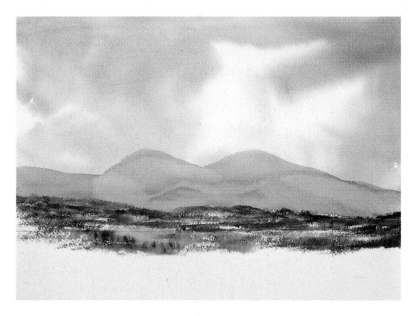

Step 4 Fun – Foreground

You paint the foreground with a mixture of Ultramarine Blue and Lemon Yellow Hue in the same way you painted water in your first picture (one stroke).

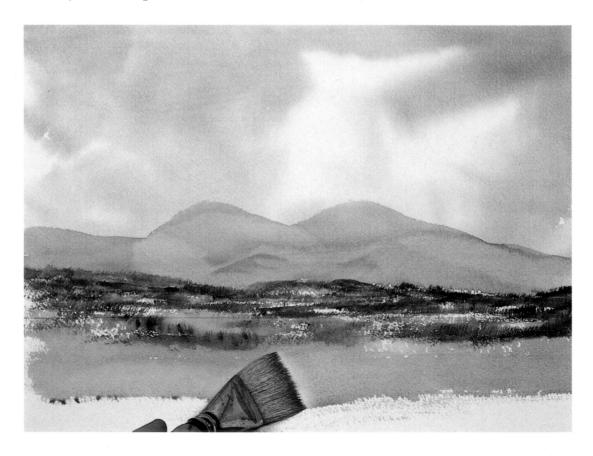

THEN LET IT DRY.
Use your hairdryer if you have one.

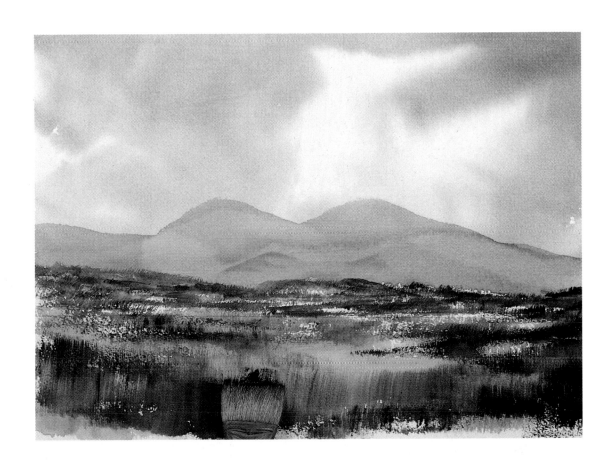

When the picture is dry, use a mixture of Raw Sienna and Burnt Umber to paint some rushes in the foreground. Do this with lots of paint on a very dry brush.

**NOW STOP
SIGN IT**

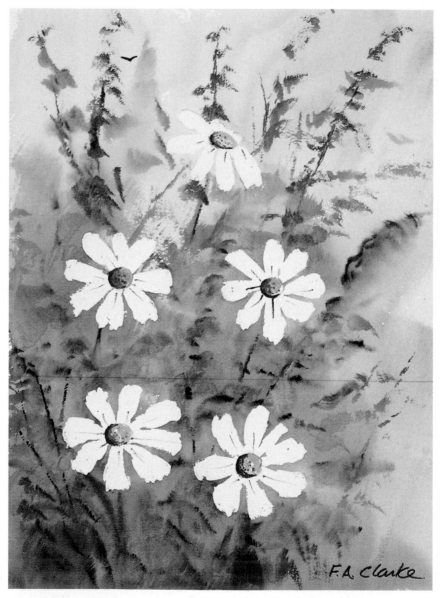

Lesson 3 **Finished painting**

7: Lesson 3
Painting Flowers in Colour

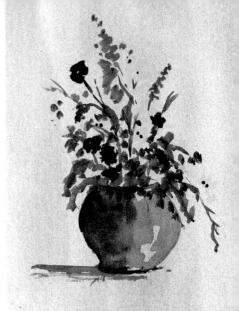

To paint this picture, you will need the following equipment:

- Large Brush – 1·5" (38mm) Winsor & Newton **Simply Painting** Brush

- Small Brush – Winsor & Newton **Simply Painting** No. 3 Rigger

- Paint – Lemon Yellow Hue, Raw Sienna, Burnt Umber, Payne's Gray

- 1 Sheet of 140lb (300 gsm) Watercolour Paper, 10" x 14" (25 x 35cms)

- Palette

- Water, Pencil, Cloth, Ruler, Adhesive Tape

- 20" x 16" (50 x 40cm) board

- A Hairdryer, if you have one

- Masking Fluid

- A small inexpensive brush to apply masking fluid.

This lesson is devoted to painting flowers, daisies in this case, using the **Have Some More Fun** method. The picture is painted in portrait which means upright as opposed to your first two pictures, which were painted in landscape.

Step 1 Have – Horizon

Affix the paper on three sides to your board in an upright position.

Take your ruler and pencil and draw a horizon line, just under half way up the page.

Use a pencil to mark where you are going to put the daisies on the paper. Look at the picture on the opposite page. First draw circles about ·5" across (12mm). Draw these freehand as they should not be exact circles.

Don't put the circles too near the edge of the paper. Three should be above the horizon line and two below. Now draw the petals around each circle. The petals don't have to be the same size. Start each petal at the tip and draw in to the circle.

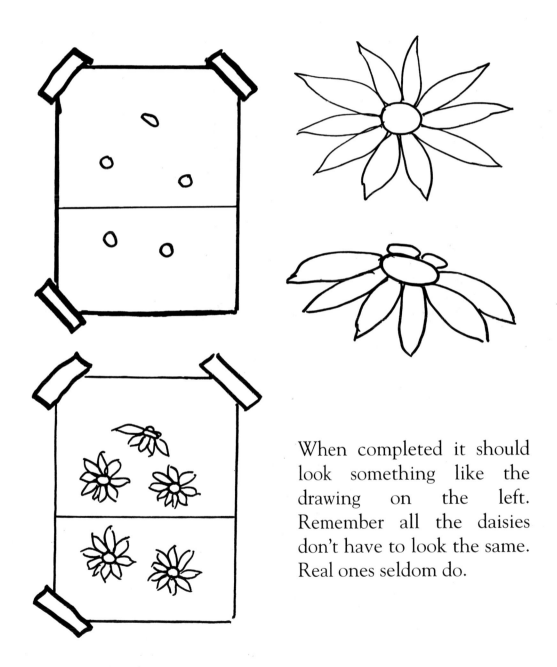

When completed it should look something like the drawing on the left. Remember all the daisies don't have to look the same. Real ones seldom do.

Now for the masking fluid. The reason I said at the start of this lesson that you should use a small inexpensive brush to apply masking fluid is because this substance can damage your good brushes.

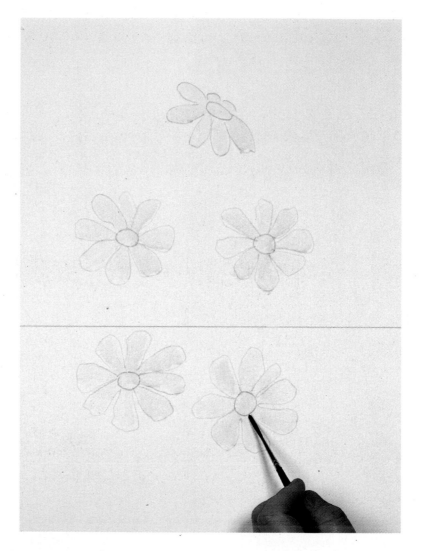

When painting with masking fluid, start at the top of the picture and work down. Dip your brush into the masking fluid. Paint the centre and the petals of a daisy. Make sure you completely cover all the flower with fluid. Repeat this process until all the

daisies are completely covered with masking fluid. Now when you paint the rest of the picture no paint will get on the flowers.

When all the daisies are covered, stop and wait until the masking fluid is dry. This will take five to ten minutes. You can use a hairdryer to speed the drying process.

Now you can start to paint the picture. Take the tubes of Lemon Yellow Hue and Raw Sienna paint and squeeze some onto your palette.

TO PAINT THIS PICTURE YOU DO NOT HAVE TO WET THE PAPER FIRST.

Using the big brush, combine equal amounts of the two colours with water into a weak mixture.

Starting at the top of the picture, paint over the entire surface, including the flowers, with this mixture.

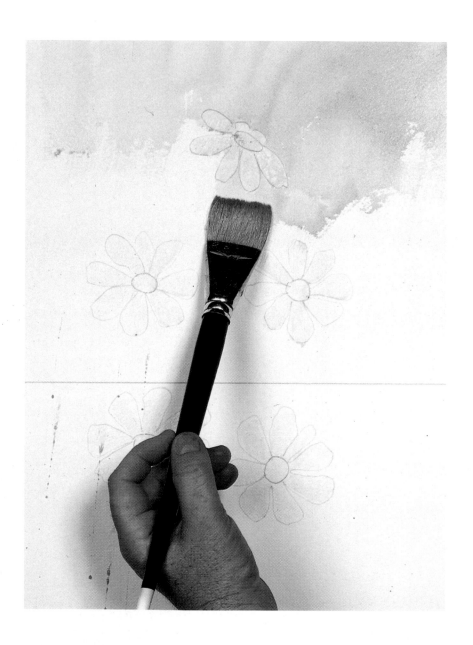

Add some Burnt Umber paint to your mixture, not too much, you just want to darken it a little. While the picture is still wet, once again paint from the top, but ignore the top left corner of the painting.

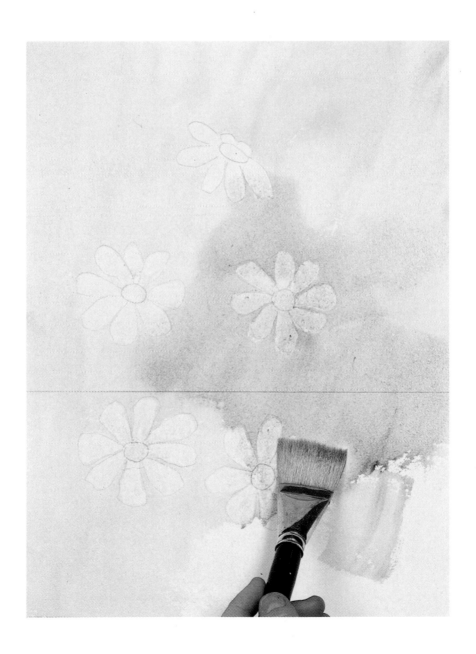

Using very little Payne's Gray add some to the mixture and darken the bottom left corner.

TIP: Don't use too much Payne's Gray as it is a very strong colour.

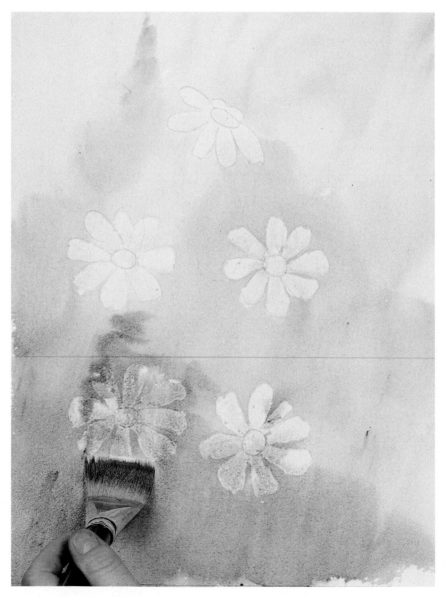

LET THE PICTURE DRY.

Now with the large brush draw some stalks and leaves onto the daisies. Use a mixture of Burnt Umber and Raw Sienna. Paint over the daisies – they are still protected by masking fluid.

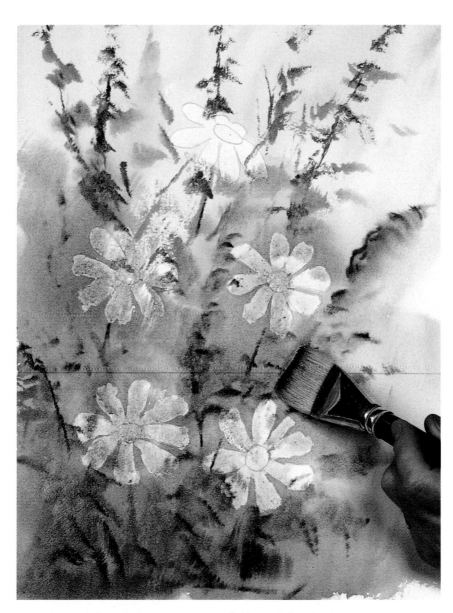

ONCE AGAIN STOP AND LET THE PICTURE DRY.

Next we come to the part of the painting where the picture comes to life. Having made sure that the picture is completely dry, rub off the masking fluid either with your finger or with an eraser. Always rub towards the centre of the daisy and once again, start with the daisy at the top of the picture. When you have completed this you will have five, nice pure white daisies.

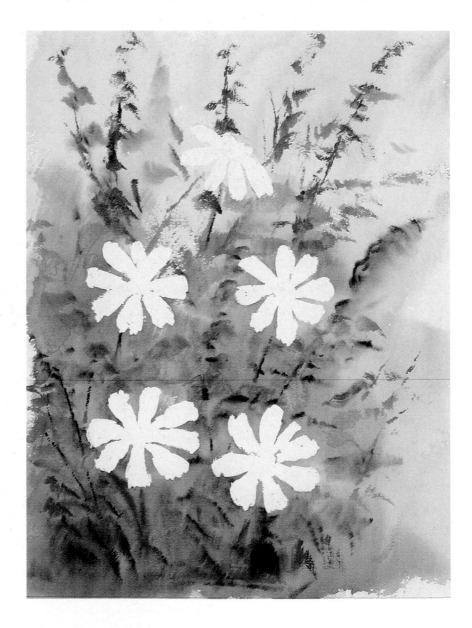

Now, using the small rigger brush, paint the centre of each daisy with a mixture of Lemon Yellow Hue and Raw Sienna. Remember to start at the top of the painting and work down. Now use the Burnt Umber, and paint a line similar to a half moon, on the bottom left of the daisy's centre. Complete the daisy's centre with little dots of Burnt Umber.

Now move down to paint the next daisy.

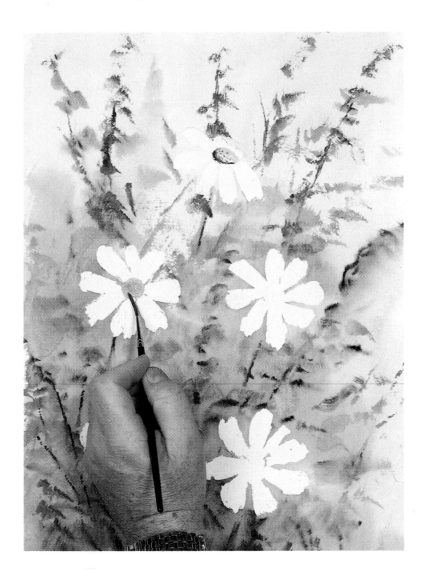

Finally using the rigger brush and again the Burnt Umber paint, draw a fine line in the centre of each petal. This line represents the flower's spine.

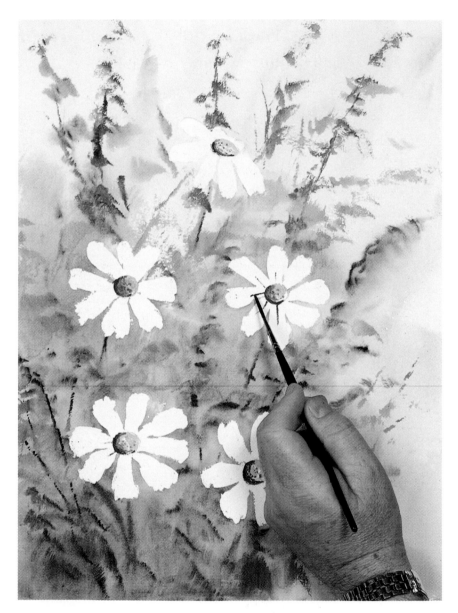

**NOW STOP
SIGN IT**

8: Frame Your Pictures

I will now let you into a little secret. If you frame any of your painting lessons from this book, you will be amazed how good they look. Artists will tell you, a picture is not a picture until it's framed, particularly a watercolour.

A good way to judge your finished paintings is to view them through a Mount (or Mat).

To make a simple Mount or Mat, obtain a sheet of white paper (or coloured if you prefer) 18" x 14" (45 x 35cm).

18" (45cm)

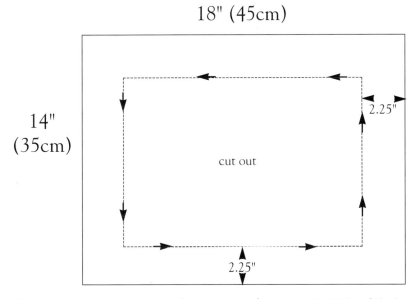

14"
(35cm)

2.25"

cut out

2.25"

Cut out the centre leaving about a 2·25" (5·5cm) border all around. Place the border over your finished picture and see the difference.

It is always a good idea to get the help of a framing expert. Go along to your local picture framer and ask for advice on framing. Don't be shy, take your pictures with you and see how well they look in a frame.

9: Figures in Landscapes

What I have tried to do in this book and in particular in this section is to simplify painting methods and terminology. When you attend any amateur painting exhibition one of the things you will notice is the lack of figures in the pictures. There is a simple reason for this, most amateur painters do not put people into their landscapes because they are afraid of ruining their paintings.

We are given to believe that to paint the human form we must first attend a course in anatomy and having finished this we must become as capable with pen and paper as Leonardo Da Vinci. Only then, having driven ourselves almost to frustration by painting arms, feet and heads can we think of putting figures into our paintings.

Nonsense, I say. If you look at most landscape paintings with people in them you will notice the figures have no hands or feet and very little facial features. It is only the **impression** of a human being that is conveyed.

Now if you want to follow in the footsteps of Leonardo by all means do so. But if you want to paint simple figures in your landscapes then I will give you a little exercise.

What I would like you to do is forget people and paint **CARROTS!** Use the small brush and Burnt Umber paint to do this exercise. In case you haven't seen one in your local vegetable shop, let me explain what a carrot looks like. A carrot is wider at the top than the bottom and is not a symmetrical object

Now paint some carrots.

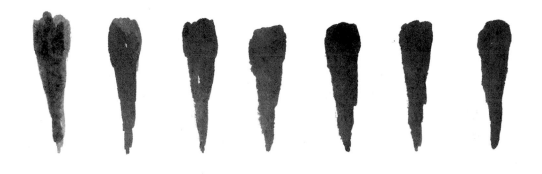

When you have completed about twenty carrots you will find number twenty is better than number one. Practice makes perfect.

Now put dots on top of the carrots. Don't make them too big.

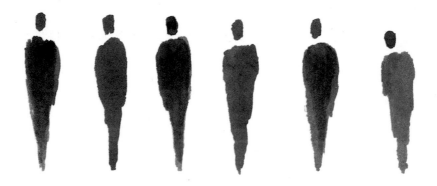

Voila! – People

Now the people you have just finished, probably look more like men than women. Why is that? Well, back to the paper. Again draw two more carrots for me. When you have completed the carrots, the male carrot's head is always separated from his body. This is quite normal with male carrots, whereas the female of the species has her head very well attached to her body, it's her hair you see. So with one there is a gap between the carrot and the head and with the other there is no gap. Do that for me now; there is your male and female carrot.

Baby carrots have smaller bodies, but their heads are as big as a full grown carrot.

Leave a white face for a carrot walking towards you.

Well done, you have just had a crash course in anatomy and can in future put figures into your paintings.

10: Boats, Bridges and Cottages

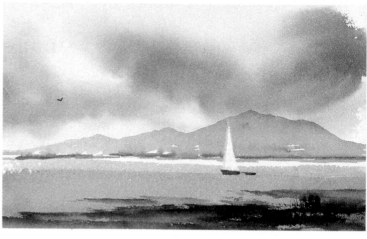

Let's start with boats. The first part of the boat to be painted is the hull, in other words, the part that is in the water. Start by painting a rectangular shape about 1.5" long and .25" high (38 x 6mm).

On each end of this rectangle paint a triangle, this gives us the stern and bow of the boat.

At the left side of the boat paint the top half of a carrot. When you have this painted, put a dot above it. Now there is a man in the boat.

As with the carrots, practice this and you will improve.

Bridges

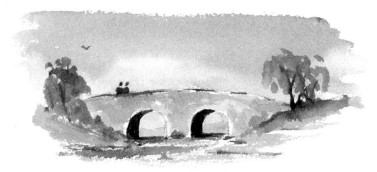

Our next subject is a bridge. A bridge is a covered arch, and we simplify it by thinking in terms of the letter 'U' upside down, this is the arch of the bridge. Using your pencil, draw the letter 'U' upside down.

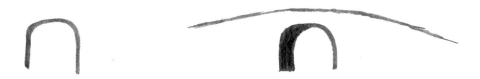

Make the 'U' thicker on one side to give the impression of depth. When you have that completed, draw a curved line across the top, about a ·5" (12mm) above the arch.

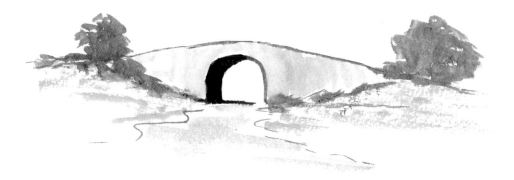

There's your bridge. You can bring the river bank down on each side and you've got a scene. You are nearly an instant artist, but a little practice is no harm. As with the carrots and the rectangles, you will find if you draw twenty of each of these, the twentieth will be better than the first.

Here is a simple bridge scene for you to try, using the **Simply Painting** method.

Remember:

Horizon
About one-third up the page.

Sky
Cobalt Blue Hue with a little Arizarin Crimson.

Middleground
Above the Bridge –
Raw Sienna, Lemon Yellow Hue, Cobalt Blue Hue and a little Burnt Umber.
Bridge –
Payne's Gray
Water –
A stronger mixture of Cobalt Blue Hue than used in the sky.

Foreground
Rocks –
Payne's Gray
Other Areas –
Lemon Yellow Hue, Raw Sienna and Cobalt Blue Hue.
Reeds –
Burnt Umber.

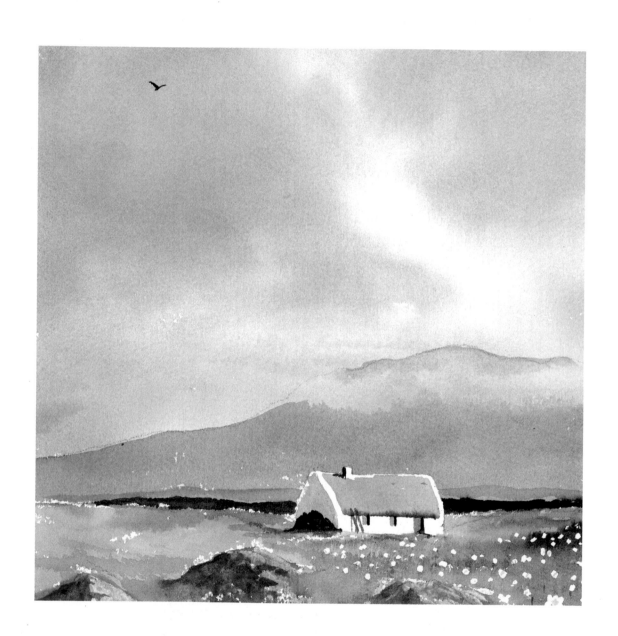

Cottages

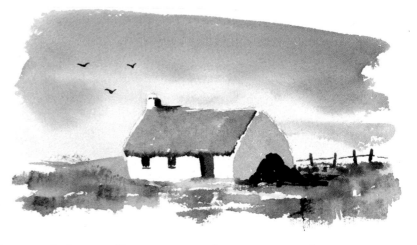

You do not have to be an architect to draw a cottage. After all a cottage is only a low squat building. None of the walls are straight nor are the windows or doors perfect rectangles. Here is a simple method for sketching a cottage.

Take your pencil and lightly draw two letter 'V's upside down.

Now join point A to point B and point C to point D, as below.

Next, put three legs on the roof as below.

To draw the windows, once again we simplify. Draw the number 1 where you want to place the windows, but keep them up close to the roof. The door is just a larger number 1.

Now, I find that most people when painting cottages make the distance from the eaves to the ground too great. The roof should be twice as high as the front wall of the cottage.

Finally, we need a chimney. This is just a box on the roof.
Do this exercise ten times – practice makes perfect.

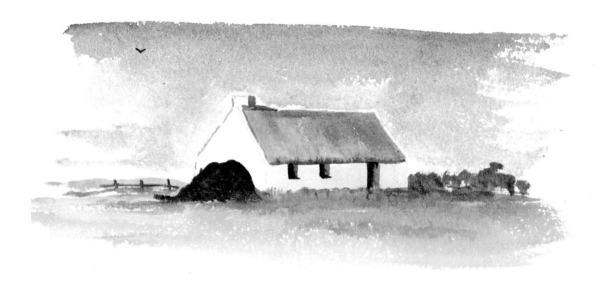

TIP: You can use masking fluid on the cottage to protect it while you paint the rest of the picture.

11: Wet into Wet Painting

What on earth does Wet into Wet mean? Let me explain, when you wet the paper, it turns into a type of blotting paper. This allows the paint to soak and spread on the surface of the paper and prevents hard edges. It creates wonderful subtle patterns.

You will never be able to totally control the paint which is in itself part of the fun. Wet into wet is the technique you used when you painted the first two skies. It can also be used to create misty scenes.

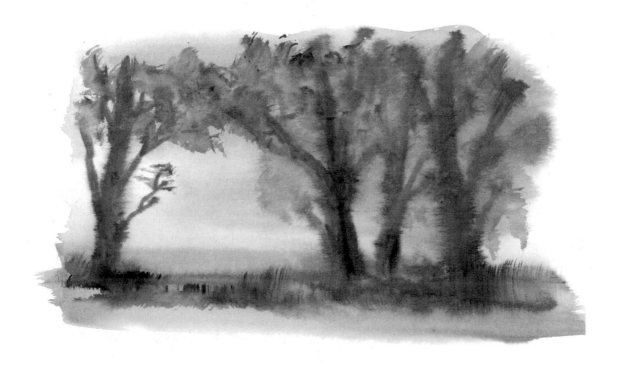

12: Graded Wash

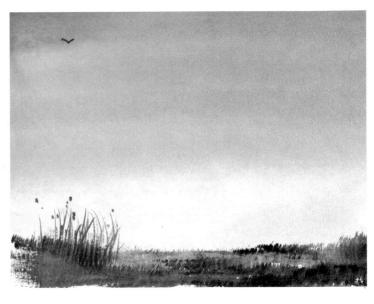

A graded wash is a painted area light at one end and dark at the other. To create a graded wash simply start at the top of a sheet of dry paper and paint a strip of dark colour, then adding more water to your brush make a second strip under the first. Keep doing this and you have a graded wash. For example, to paint a sky using a graded wash, start at the top of the paper with your darkest paint and use more water, less paint as you descend.

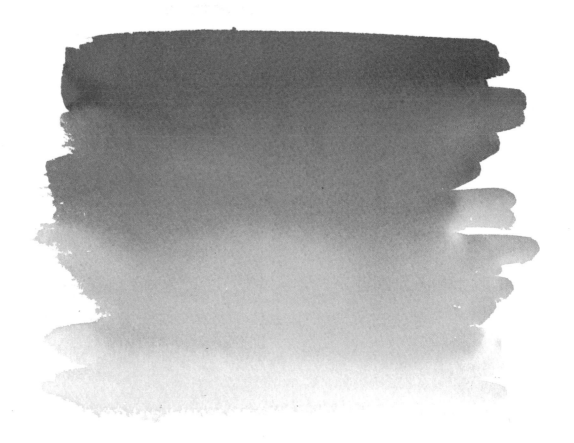

13: Skies

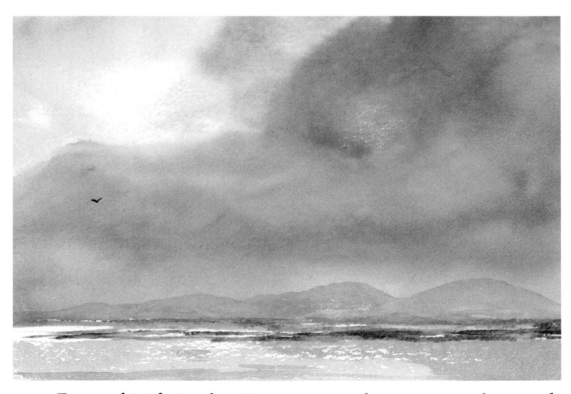

At last we come to my favourite part of any watercolour painting – the sky. Let me start by saying "get the sky right and the rest of the picture will follow".

I have a method of painting skies which I want you to follow. It works like this – from the time you wet the paper you imagine there is a clock ticking with a hammer tied to it which runs for two minutes. At the end of the two minutes, if you have not completed the sky, the hammer hits you on the head.

Remember from the time you wet the paper you have only two minutes to complete the sky.

What happens if you don't complete the sky within two minutes? The paper starts to dry and consequently the brush leaves unacceptable marks all over your lovely sky. **The moral is paint skies quickly and don't fiddle.**

Even though you have only two minutes to paint the sky it is a good idea to try to plan the outcome. So before you start to wet your paper, plan where you would like the light and dark areas in your sky and try to follow this plan.

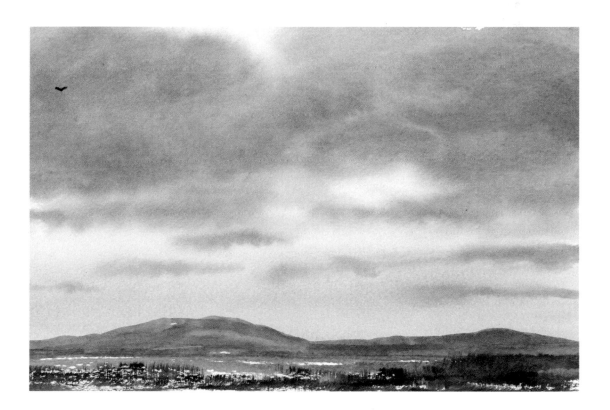

Don't worry if the sky does not come out as you wanted when wet. I say, when wet, because as it dries a sky softens and

lightens and what may not look good when wet may dry out beautifully. So give it a chance. However if it fails, as mine sometimes do, just turn over your paper and start again.

One final piece of advice, paint a sky a day and your watercolour painting will improve in leaps and bounds. It is my firm belief that if you can paint skies you will have no trouble becoming a competent watercolourist.

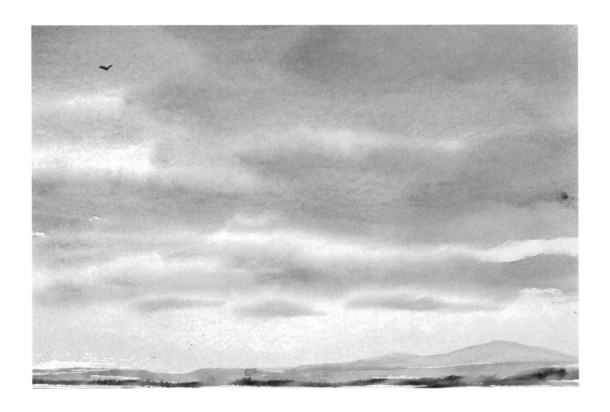

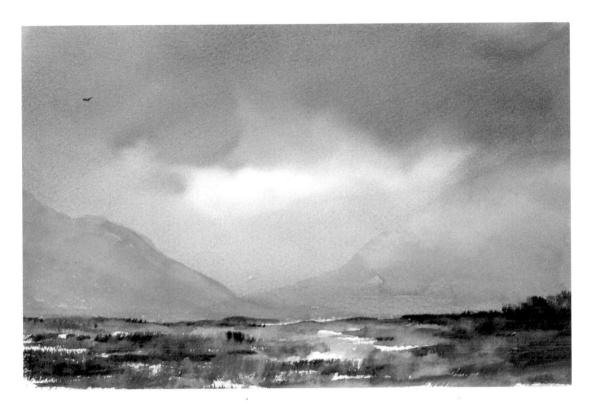

To Recap

1. Try to plan your sky.

2. When the paper is wet you have two minutes to complete the sky or watch your head.

3. Remember skies lighten when dry.

4. Paint a sky at day.

5. There are two sides to all watercolour paper, and you can use both sides.

14: Water

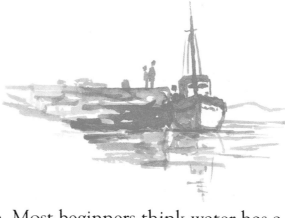

Water is generally clear
so it reflects its surround-
ings; the sky, mountains,
trees and of course sunshine. Most beginners think water has a
colour of its own and therefore create pictures with the sky
bearing no relation to the water. This can spoil any picture.

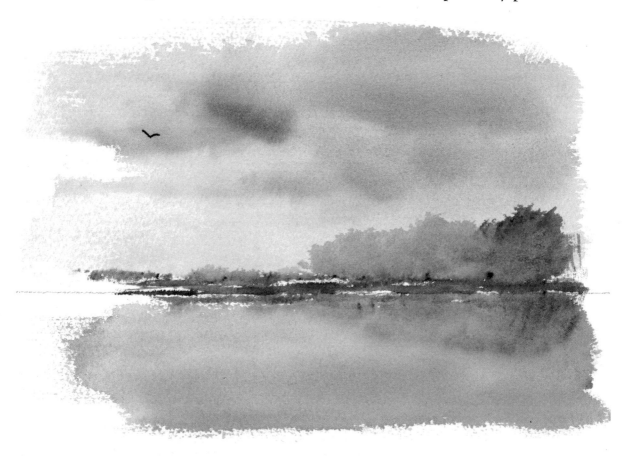

When you look at a red sunset you will find that the water
reflects the red sunset. The colours water can reflect will
surprise you. For this reason I cannot over-emphasise the

importance of looking at nature, believe me, I learned the hard way. For a long time, I was not seeing the joyful colours of nature because **no one told me to look**.

Now my wife and best pal, Peg, won't let me drive in my beloved Connemara. She says I never look at the road as I am too busy admiring the wonders of nature and painting mental pictures.

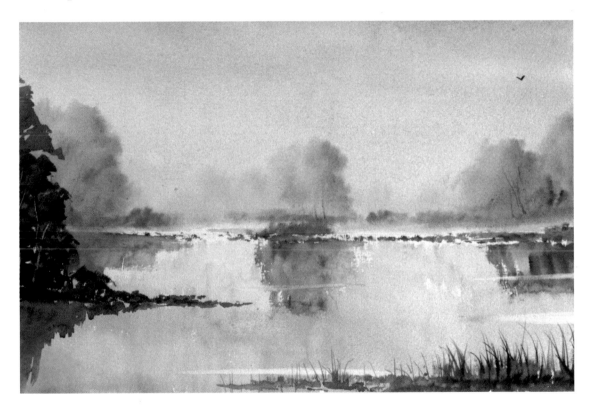

To Recap

1. Water reflects its surrounding colours, so use these surrounding colours when you are painting water.

2. Water reflects sunlight.

3. Remember to look at the colours of nature.

15: Trees

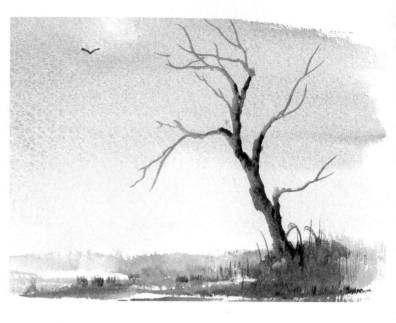

As described in the first painting lesson, trees grow from the ground up and should be painted in this way. The second point is that trees are not telegraph poles. They grow to the left and to the right.

Be careful not to make the tree trunk too thin, it should be big enough to support the tree, even in a storm. My advice is to go out and look at trees. In fact, the budding artist in you, will probably begin to really see nature for the first time.

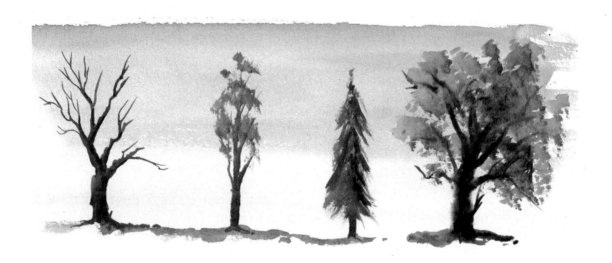

The foliage of trees can be many colours depending on the season and the time of day.

All of the colours below were created using mixtures of Lemon Yellow Hue, Ultramarine Blue, Raw Sienna, Burnt Umber and Payne's Gray. Try and reproduce these colours on a scrap of watercolour paper.

TIP: Don't mix more than three colours together and be very careful when using Payne's Gray, it is a very strong colour.

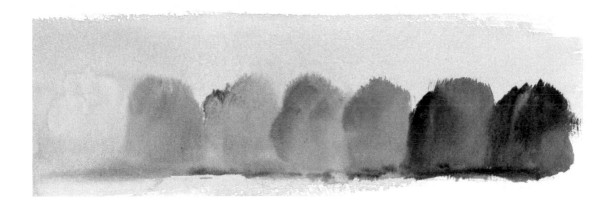

Students often say to me "Until I started painting I never realised there were so many colours in nature". So the lesson is **look** and see, **there is much to discover**.

16: Light and Shade

Light and shade is seeing where the light originates from and conveying this in your painting.

When you painted the monochrome picture (page 30), you painted reflections on the water which indicated that the light was coming from behind the trees over the mountains. The use of light and shade is a skill which will develop as you paint. Observe nature, see how the light changes as the day progresses, how each season has it's own light and how that light interacts with the landscape. Experiment with your own painting but don't go overboard putting shadows all over your pictures, it will come with practice.

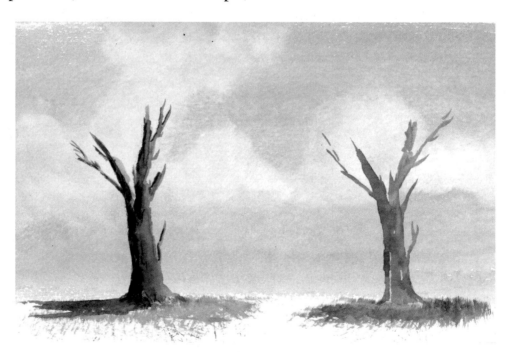

With light and shade *Without light and shade*

17: Sketching

Many budding artists will try to skip this section saying, I can't draw a straight line. My answer to that is, you have a ruler!

Let me draw your attention back to the carrots. If you have followed the book correctly you can, by using the carrot method, draw a man, a woman, and a child. You can also sketch boats, bridges and cottages. So is it wrong to say you can't sketch?

The word sketch means, a rapid drawing or painting for subsequent elaboration. So how do you sketch? Using a pencil draw a horizon line and then freehand draw a brief outline of what you want to paint (you can rub out mistakes). You should make notes concerning colour etc. on your sketch which can be used later when painting the picture.

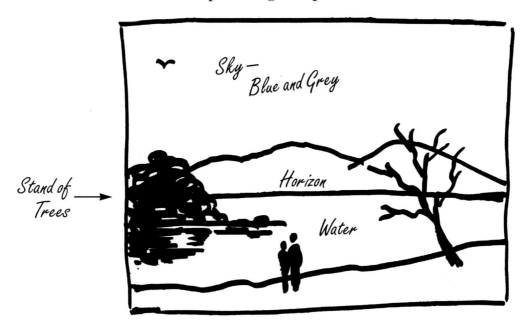

You will see from the previous illustration everything is freehand and sketchy with little detail. Note the use of carrots.

You don't need to be an architect to sketch. A sketch is only a reference or guideline for future painting. I do many sketches

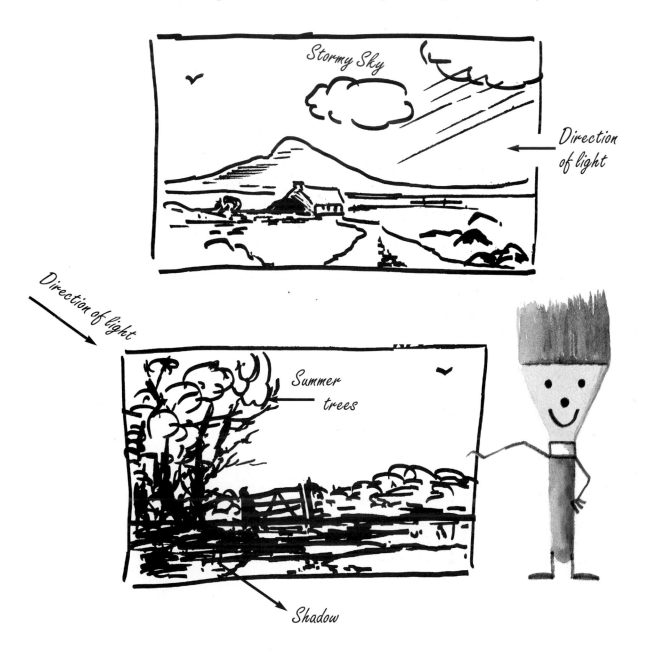

on scraps of paper, even beer mats, just to have something which will refresh my memory when I start to paint the subject.

So to sketch you need a pencil, eraser and a sketch pad. Try some yourself.

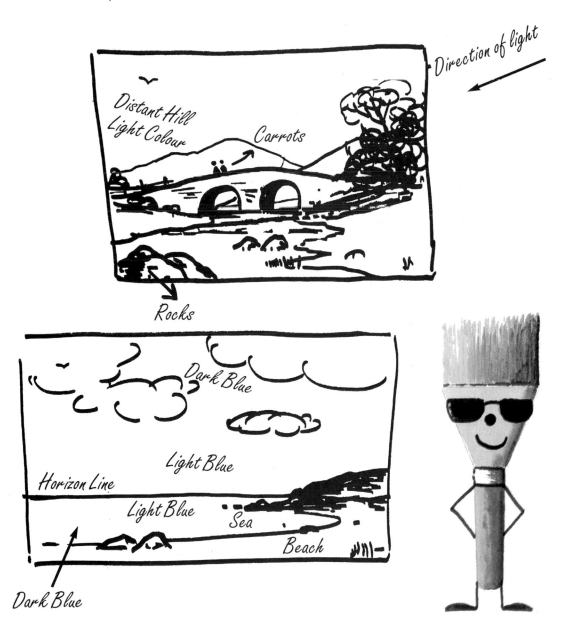

To Recap

1. Draw the Horizon line first.

2. Keep sketches simple.

3. Take notes of colour.

4. Always take a sketch pad, pencil and eraser when you go out – you never know what might catch your eye.

18: The Camera

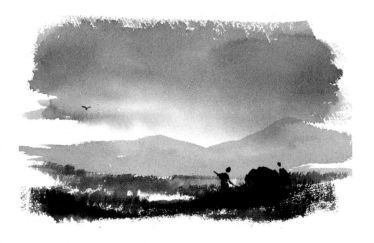

I often think how lucky we as modern artists are, having the camera to assist us. Now you will notice I said assist. Most artists use photographs as a source of information, and in this way, the camera can be of great assistance.

Having made this point let us talk about the use of photographs when painting. There is no doubt that having photographs of the scene you wish to paint will help you in the composition of the picture and give you some idea of the colouring. I have selected my words with care for a very good reason. I want you to think of your camera as a sketchbook. When you go out walking or sketching, take your camera along.

When you find a scene which you would like to paint, take a photograph. If there is a large telegraph pole in your way, don't worry. Your paint brush is mightier than the largest bulldozer and when painting your picture you can just leave it out. Many people will forsake the best angle forgetting what I have just said. The same applies to anything in the photograph you don't like. In this way your camera can be used as a sketch pad.

An important point to remember is, don't try to paint a mirror image of the photograph, simplify the scene. Don't attempt to include every detail. Take the main features and forget the rest.

If you remember the meaning of the word sketch, referred to in the section on sketching, you will now begin to understand what I am saying. You will also become a better photographer, for the simple reason that you will be composing pictures with your camera.

Now about colour. I have already mentioned that photographs will give you some idea of colouring. The reason I said this is because photographs don't always reproduce the colours of nature. But they will give you some ideas.

If a fellow artist tells you that using a camera is cheating, your answer should be that there are very few, if any, modern landscape artists who do not use photography as a reference. Use your camera, take it with you – it will be a great help.

A couple of words of wisdom. Beware of the friend who has heard you have taken up watercolour painting and is kind enough to bring you home a photograph of the parade in New York, complete with marching bands and skyscrapers and wants you to paint a picture of this photograph. It is better if you paint from photographs you have taken yourself and start with simple scenes.

To Recap

1. Use your camera as a sketchbook.

2. Don't try to paint a mirror image of the photograph.

3. Remember the paintbrush is mightier than the bulldozer.

4. Start with simple scenes.

5. If possible use only your own photographs.

6. Anyone who says using a camera is cheating is only cheating themselves of a valuable asset.

19: Your Studio

One of the nice things about painting indoors is that you can work in all weathers at any time of the day or night. If you are lucky enough to have a spare room that you can convert into a studio, great!

Watercolour painting is clean by comparison to other painting mediums and when I started to paint I was able to use a corner of the lounge. This posed the problem of having to move when guests called, but this could not be avoided. In time our home slowly turned into an art studio. Since I built my studio, Peg has regained the house and now I can work when I like without distraction.

The first thing an artist needs in a studio is good light, preferably daylight. If you can work by a window during daytime all the better. If not, this can be achieved by purchasing daylight bulbs from an electrical store. These give good daylight effect and are worth having; they are also inexpensive.

In a studio one piece of equipment which can help your painting greatly is a proper drawing board. This can be as simple as the board referred to in the section on equipment, but if you can acquire an architect's drawing board, all the better. Mine is free standing and I can tilt it to any angle I

desire. These can often be purchased secondhand for very little, so keep a look out.

Another asset in a studio is a sink with running water. This allows you access to clean water without disturbing others.

Of the many other things I could suggest, heating, a comfortable chair and enjoyable music can all be beneficial.

20: Do's and Don'ts

Horizon line

Never centre the Horizon line.

Horizon line

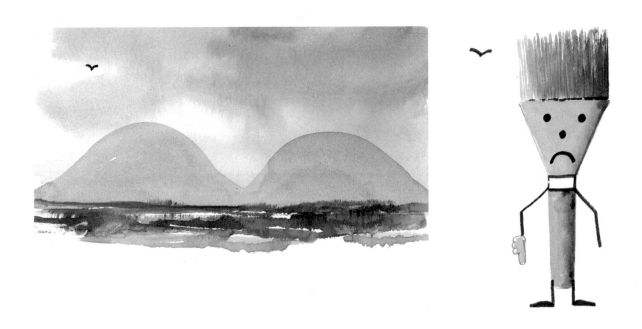

Mountains should not be too rounded.

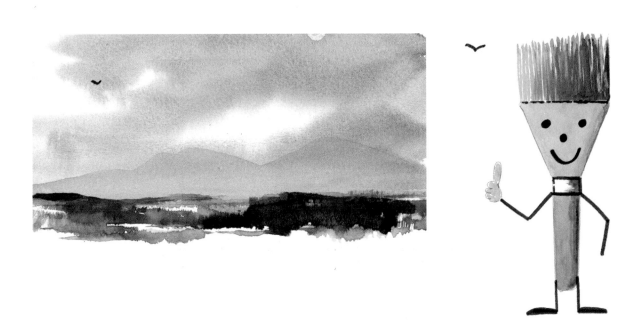

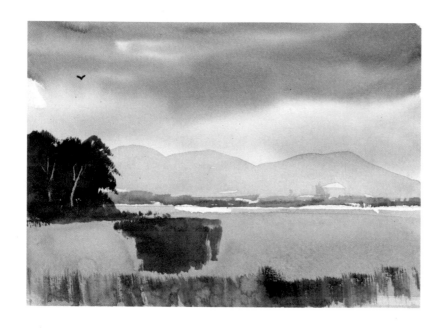

A shadow should be a mirror image of what
it is reflecting.

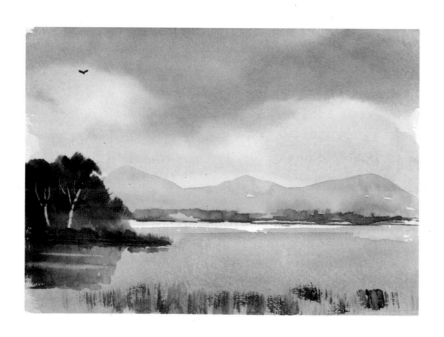

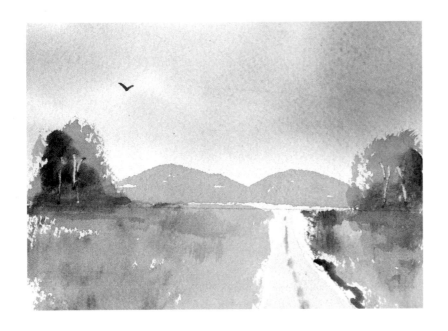

The right and left sides of the painting should
have different features.

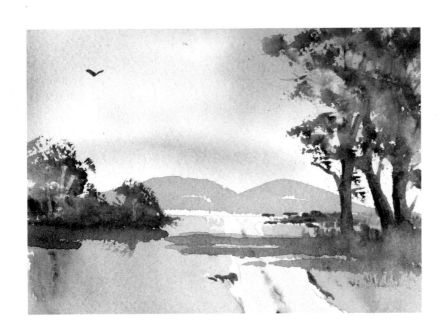

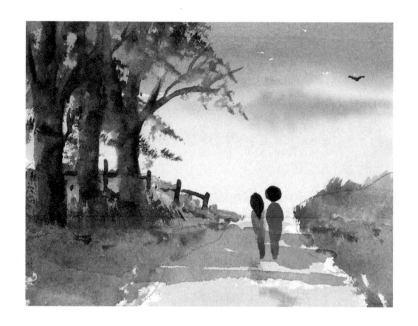

Heads should not be painted too large.

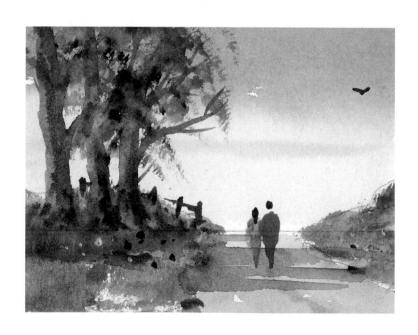

The painting's main point of interest
should not be in the centre of the picture.

21: Points to Remember

1. **Handle your watercolour paper with care**, even the cleanest hands leave some grease which can mark your paper.

2. **Purchase only the colours you need**. Remember by mixing your paints you can produce many other colours.

3. **Your paper is your white paint.**

4. **Paint is inexpensive**, so don't be afraid to use it.

5. **Don't let your palette become too wet**.

6. **Use the large brush as often as possible.**

7. **Start painting from the top of the paper.**

8. **Keep referring to the subject you are painting.**

9. **Keep looking at the painting in progress**. Stand back from your picture and you will see it better.

10. **Paint a river in one sweep**. Imagine the paint is flowing off your brush onto the paper exactly as a real river would.

11. **Paint trees as they grow**. Remember, they are not telegraph poles, they grow in all directions.

12. **A hairdryer will help speed up the drying process.**

13. **Practice makes perfect, so keep at it.**

14. **Don't Fiddle.** When your painting looks complete, resist the temptation to keep adding extra touches.

15. **Finish one painting before starting another.**

16. **Remember the *Simply Painting* motto – *Have Some More Fun*.**

22: Simple Paintings to Try

In this section of the book I want you to try some simple pictures of your own. Use the pictures contained here as a guide. All the pictures have been painted using the **Have Some More Fun** method and contain boats, cottages, flowers, mountains, water, skies, trees and of course carrots.

You should, by now, be able to paint all of these. You might like to paint the first lesson again and this time insert a boat on the lake. Perhaps paint the second lesson putting in some carrots or even a cottage. Remember to break down your pictures into the four main components: **Horizon, Sky, Middleground and Foreground**.

Experiment with what you have learned so far, combining the lessons to create new paintings.

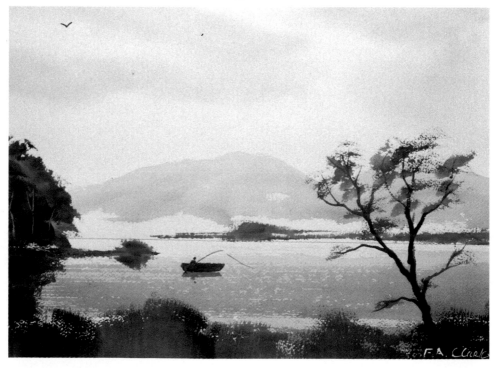

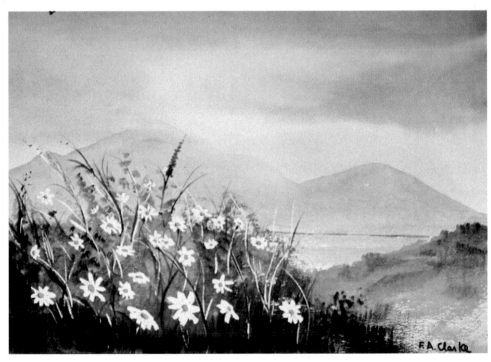

110

23: Colour Chart

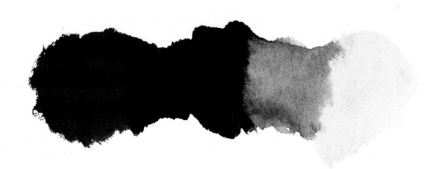

A colour chart is a reference showing what happens when you mix two or more paints together.

This section is devoted to making your own colour chart. It is very useful to your progress in watercolour painting. I did not start with it because my motto is "paint first and charts later".

Colour charts are a great help to your advancement and understanding of colour mixing and as, by now, you should have painted three pictures (at least), I think it's time to try your hand at your own colour chart, which you can keep for reference. I still use mine.

In the lessons you have had some experience mixing your selection of colours to make new colours. It is now time for you to build your own repertoire. One of the delights of painting is that an infinite number of colours, shades and hues can be produced by mixing two or more colours. You are really only limited by the ability of your eye to differentiate between them.

The purpose of a colour chart is to give you a physical record of the blend of any two colours. You will be able to see at a glance (a) what colour you will get if you mix X and Y and (b) what colours you will need to mix to get colour Z. You can refer to your colour chart without having to mess about trying to get the blend right.

Here is how to start building your own colour chart. Use 140lb (300 gsm) watercolour paper.

For each blend you need two boxes with the names of the two colours written alongside. For example

Ultramarine Blue

=

+ Lemon Yellow Hue

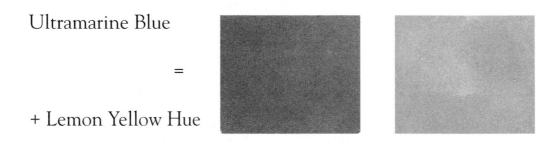

In the left box mix the colours using more of the first colour, in this case Ultramarine Blue. In the right box mix the colours using more of the second colour, in this case Lemon Yellow Hue.

This is something you must do for yourself. Start building your own personal colour chart, use the following combinations to begin with, and then add your own creations.

Ultramarine Blue
+ Lemon Yellow Hue

Alizarin Crimson
+ Lemon Yellow Hue

Ultramarine Blue
+ Alizarin Crimson

Alizarin Crimson
+ Burnt Umber

Alizarin Crimson
+ Raw Sienna

Alizarin Crimson
+ Light Red

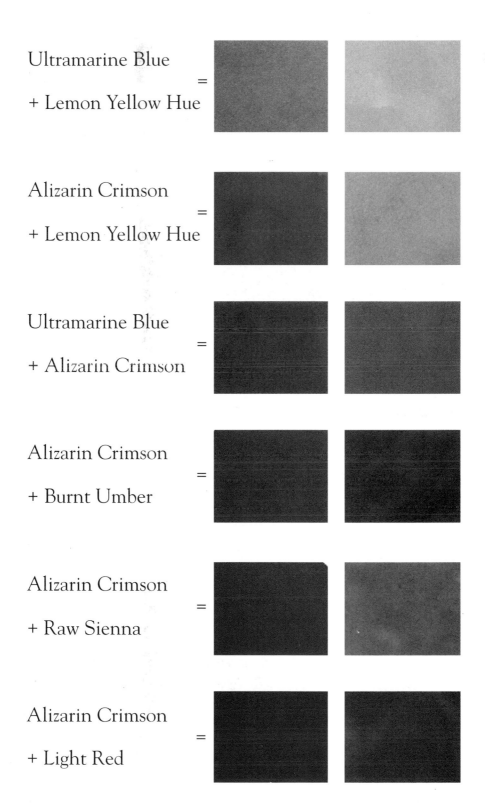

Alizarin Crimson
+ Payne's Gray

=

Alizarin Crimson
+ Cobalt Blue Hue

=

Ultramarine Blue
+ Burnt Umber

=

Ultramarine Blue
+ Raw Sienna

=

Ultramarine Blue
+ Light Red

=

Ultramarine Blue
+ Payne's Gray

=

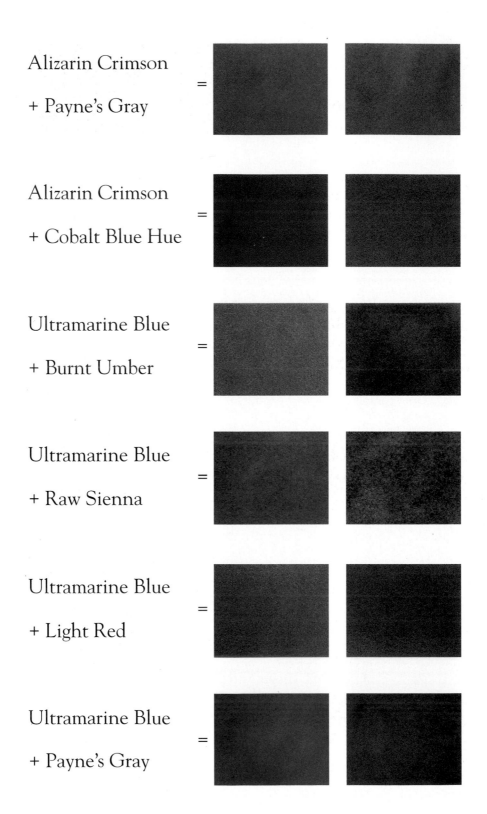

Ultramarine Blue
+ Cobalt Blue Hue

Lemon Yellow Hue
+ Burnt Umber

Lemon Yellow Hue
+ Cobalt Blue Hue

Lemon Yellow Hue
+ Light Red

Lemon Yellow Hue
+ Payne's Gray

Lemon Yellow Hue
+ Raw Sienna

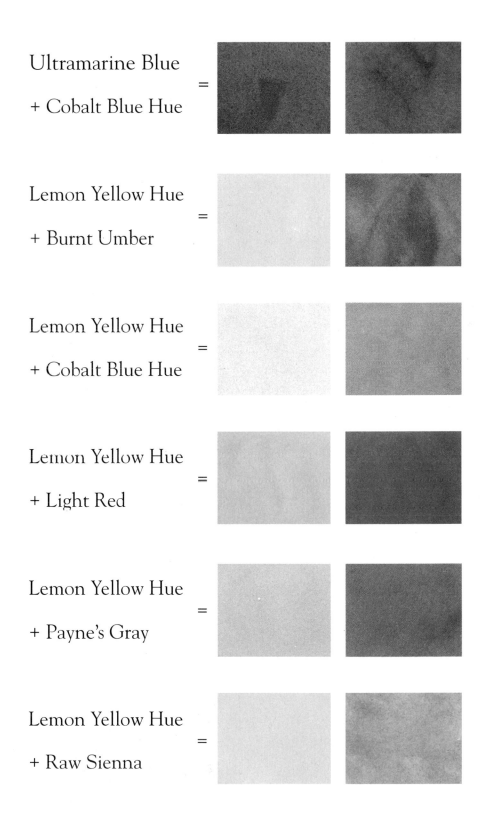

Burnt Umber

+ Payne's Gray

=

Burnt Umber

+ Light Red

=

Burnt Umber

+ Cobalt Blue Hue

=

Cobalt Blue Hue

+ Payne's Gray

=

Cobalt Blue Hue

+ Light Red

=

Light Red

+ Payne's Gray

=

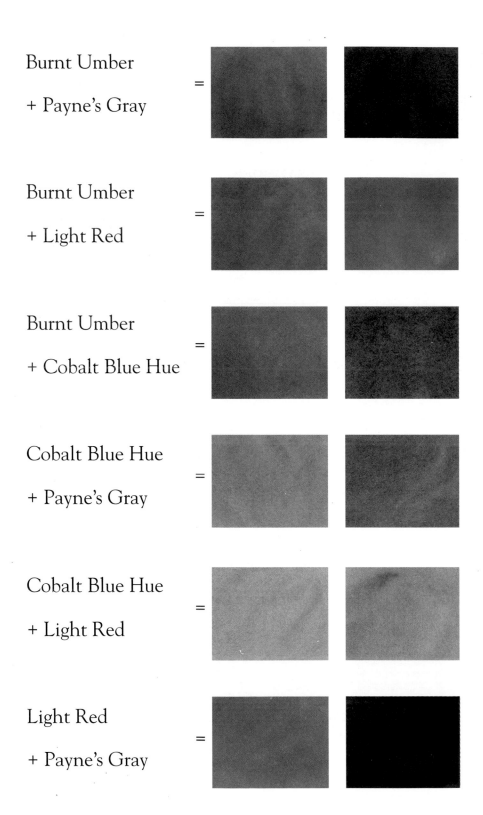

Raw Sienna

+ Burnt Umber

=

Raw Sienna

+ Payne's Gray

=

Raw Sienna

+ Cobalt Blue Hue

=

Raw Sienna

+ Light Red

=

24: Painting Classes and Painting Holidays

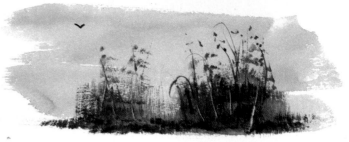

There are painting groups, artists who conduct demonstrations, painting classes and painting holidays. When I started to paint, I joined a painting group where all the members could already paint and each was painting a different picture. I ended up not knowing where to start and became very disheartened as I seemed to be making no progress. There was no real tuition.

Next I attended painting demonstrations. I learned from these outings to make sure I sat in the right seat as otherwise all I saw was the artist's back. When I could see the picture it made me realise how good the artist was, yet I was no further advanced.

This is not to suggest that there are not some excellent art teachers around. My advice would be to join an art class or go on a painting holiday where there is real tuition. Demonstrations and painting groups will be more beneficial after you have attended painting classes or have gone on a painting holiday.

I find painting holidays best. Students get a more intense grounding in the basics of painting. All my students, including complete beginners, take home at least three pictures from my painting weekends and most have them framed (all could be framed).

25: Glossary

You probably realise by now that the object of this book is to help you paint pictures without having to worry about the technical language of painting. It seems to be in the nature of all professions to create words and statements which can be confusing to the beginner. In this section I am going to give you the layman's meaning to some words and phrases which you will encounter when reading art books.

Aqueous	Any pigment or medium which is soluble in water.
Artist's Colours	The name given to oil and watercolour paints which are made from the highest quality pigments.
Charcoal	A black stick used for drawing which is very brittle and can be spread with your finger. It is made from charred wood.
Colour Wheel	A circular arrangement of the three primary colours (red – blue – yellow), showing the three secondary colours produced by mixing paints of primaries and the three tertiary colours produced by mixing paints of secondary colours.

Complementary Colours	Colours which are opposite each other on the colour wheel; for example red and green, yellow and violet, blue and orange.
Cool Colours	A term describing colours which fall in the blue range traditionally having a calming "cooling" effect on the viewer.
Dabbing	A dry-brush technique of applying small dabs of paint to the paper surface to create a rough textured appearance.
Dotting	Using a small brush, tiny dots of colour are placed next to one another.
Drawing Board	The board you affix your paper to.
Earth Colours	The range of pigments made from natural clays. They include Ochres, Siennas, Umbers, Indian Red and Terre Verte.
Ferrule	The metal part of a brush connecting the bristles to the handle.
Focal Point	The centre of interest in a painting.
Graded Wash	A wash which very gradually becomes lighter.
Grisaille	A picture painted entirely in one colour. Also called Monochrome.

Gum Arabic	A water soluble substance which is used as a binder for watercolours.
Glazing	Painting layers of paint in transparent colours.
Hot Pressed Paper	Smooth surfaced watercolour paper, for very precise work.
Japanese Paper	A highly absorbent paper that soaks up paint.
Kolinsky Sable	The finest quality watercolour brush made from the tail of the Kolinsky weasel, they are very expensive.
Landscape	Paintings of mountains, rivers etc., it can also refer to the shape of a painting, one which is wider rather than taller.
Lifting Out	A process of blotting a watercolour painting while it is still wet to remove or lift out some of the colour using tissue paper .
Lightfast	A term describing paints which resist fading when exposed to sunlight.
Limited Palette	Using a small range of colours, it is the best way to learn colour mixing.
Masking Fluid	A liquid of rubber latex in water.

Medium	Watercolour paint or any other type of substance used to paint pictures, i.e. Oil, Acrylic, Pencil and Charcoal.
Mixed Media	Using more than one medium in one picture.
Monochrome	A picture produced using shades of only one colour.
Mat/Mount	The cardboard surround which is placed around a watercolour to give it a clean finished appearance. It also prevents condensation inside the glass from damaging the work and keeps the painting from sticking to the glass.
Not Paper	A medium grain watercolour paper as recommended in this book. Also known as Cold Pressed paper.
Oriental Brushes	Soft versatile watercolour or ink brushes which have hollow bamboo handles with fine goat, weasel or badger hair bristles.
Ox Gall Liquid	A substance which can be added to watercolours to improve their flow and appearance.

Palette	This refers to both the implement (tray) for holding and mixing your paint and also to the assortment of colours used to paint a picture.
Permanent Colours	Paints which retain their colour better when exposed to sunlight.
Pigments	Substances that provide colours.
Plastic Eraser	A modern eraser made from plastic. Removes marks with very little pressure.
Portrait	A painting of a person. It can also refer to the shape of a painting i.e. one which is taller rather than wider.
Portfolio	A large folder for holding finished paintings.
Primary Colours	The colours which cannot be mixed from other colours. Consisting of Red, Blue and Yellow, and they can in theory be mixed to create all other colours.
Simply Painting Brush	Large Goat-Haired Brush 1.5" (38mm) as used in this book.
Sketch	A rapidly drawn record of a subject.

Support	The surface on which you paint.
Thumbnail Sketches	Very small rapid drawings.
Tone	The degree of lightness and darkness of a colour.
Transparent Paints	Paints which allow the underpainting to show through.
Warm Colours	A term describing colours which fall into the red range, thereby having a warming effect on the picture.
Wash	A well diluted layer of watercolour applied to the paper surface.
Watercolour Paints	Transparent luminous colours made from powdered pigments bound in gum arabic and thinned with water.
Winsor & Newton	A leading manufacturer of artists' materials

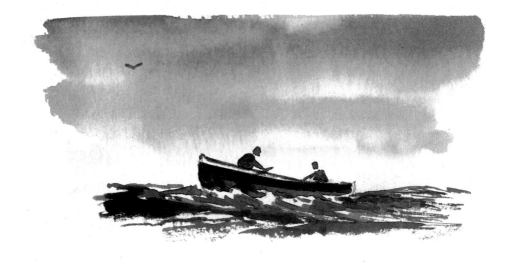

The Last Word

Dear Reader,

People may say "you will all be painting like Frank Clarke". Once again I say rubbish. Originality, "don't worry about your originality you could not get rid of it even if you wanted to. It will stick to you and show you up for better or worse in spite of all you or anyone else can do". This statement was not made by me but by Robert Henri, one of the world's greatest art teachers.

After you have spent time painting landscapes you will almost certainly begin to see nature in all its glory through fresh eyes.

In my experience as a painting teacher, I constantly meet students who come to me after only one or two lessons and confess they never realised that trees and mountains had so many diverse colours and shapes. Some of these students even grew up in the countryside. Their interest and love of nature has grown, and they now have two fabulous hobbies, painting and nature. I have also noticed that learning to paint is like riding a bicycle, once you make that first adventurous breakthrough you never forget the skills you have learned.

I hope you have enjoyed **Simply Painting** and will continue to paint and **Have Some More Fun.**

Frank Clarke

For information regarding Frank Clarke's painting classes and materials used in this book contact.

Simply Painting
P.O. Box 3312
Dublin 6W, Ireland.

Enclose a stamped self-addressed envelope.